FROM THE FILMS OF

Harry Potter™

THE WAND COLLECTION

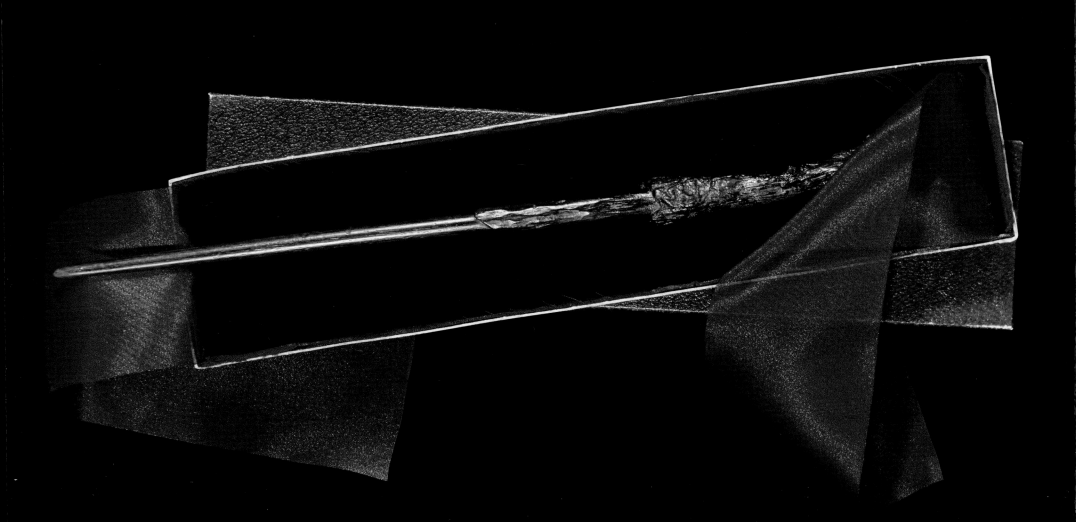

FROM THE FILMS OF

Harry Potter

™

THE WAND COLLECTION

MONIQUE PETERSON

INSIGHT
EDITIONS

San Rafael • Los Angeles • London

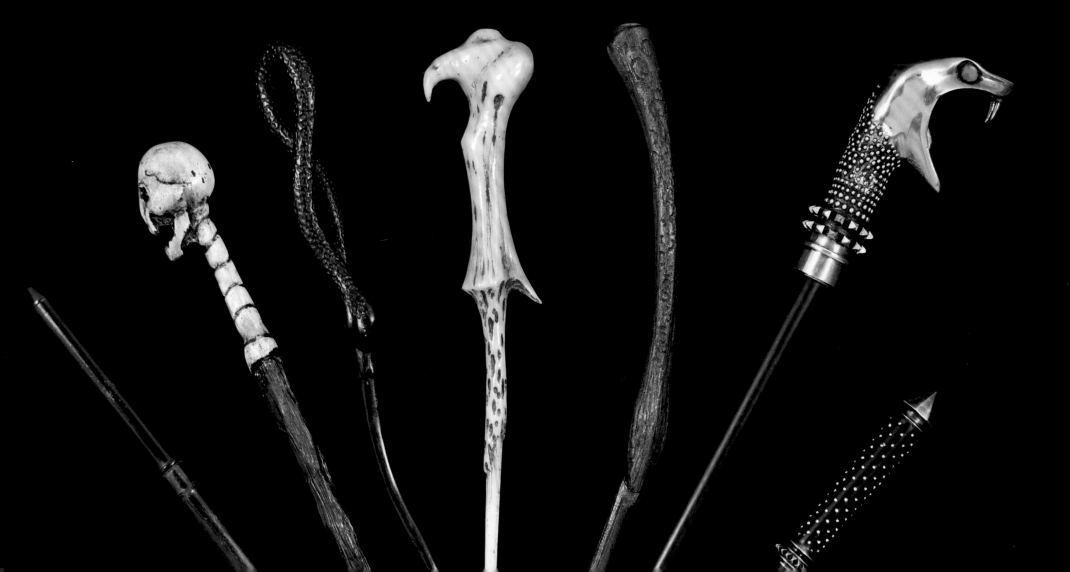

CONTENTS

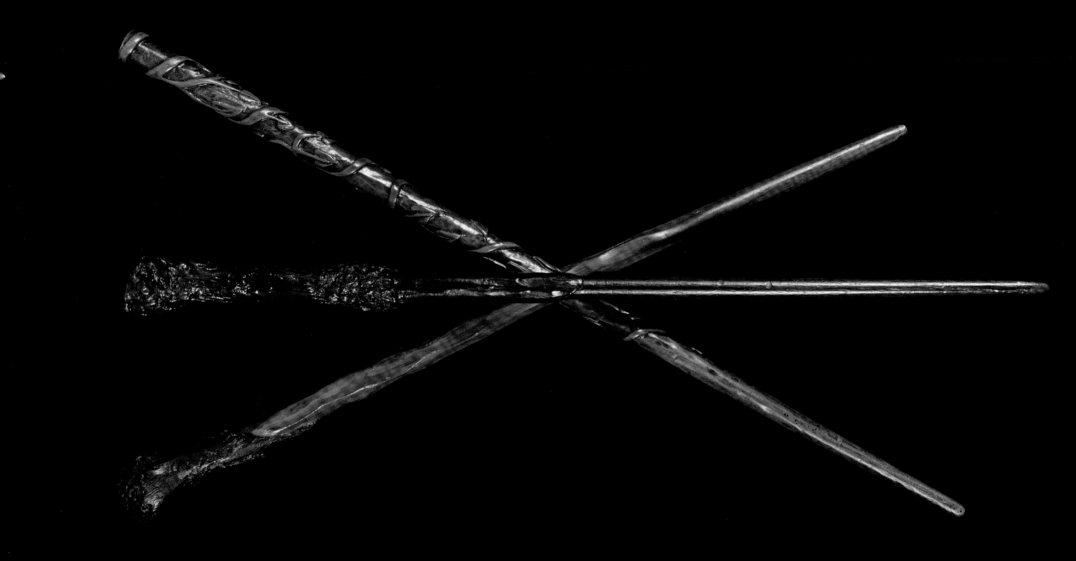

Introduction

In the world of magic, a witch or a wizard is incomplete without a wand. It is more than a tool; it is a force, an extension of intent. It embodies the very character of its holder.

In J.K. Rowling's wizarding world, wandmakers have been fine-tuning these handcrafted instruments of magic for more than two thousand years.

Harry Potter: The Wand Collection takes a closer look at these magical wands, their makers, their masters, their powers, and their legends. From the filmmakers who designed and crafted them to the actors and characters who wielded them—all played a part in making the magic wands come to life onscreen.

Every wand has a story of its own.

THE WAND OF
HARRY POTTER

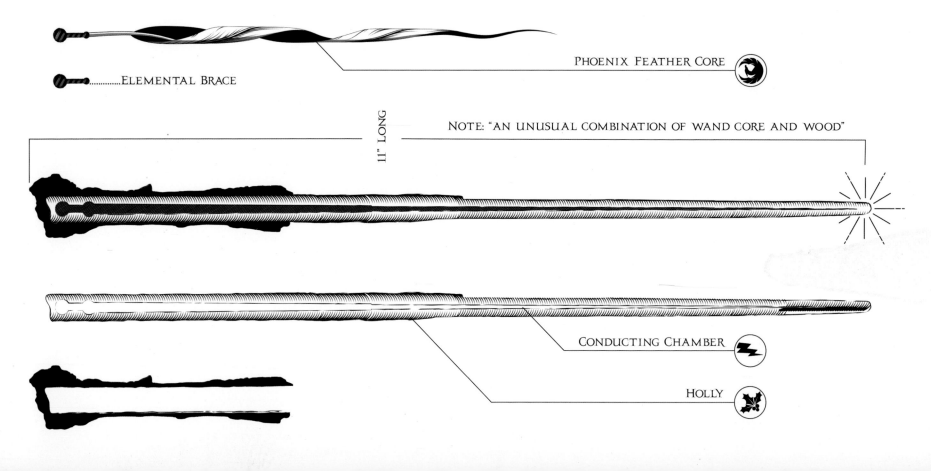

PHOENIX FEATHER CORE

..............ELEMENTAL BRACE

11" LONG

NOTE: "AN UNUSUAL COMBINATION OF WAND CORE AND WOOD"

CONDUCTING CHAMBER

HOLLY

WHAT IS A WAND?

"You talk about wands as if they have feelings."

—Harry Potter to Ollivander, *Harry Potter and the Deathly Hallows – Part 2*

In the wizarding world, a wand is a device that allows its holder to channel his or her magical powers for greater, or at least more complicated, effects. As with many acts of magic, the art of crafting a magic wand requires certain materials and rituals.

When creating a wand, special attention is paid to selecting a core. Wandmakers choose something from a magical creature, such as the feather of a phoenix or the hair of a unicorn.

The core is then inserted into wood, such as willow, ash, yew, or holly. The specific material used to create a wand is important. Certain woods have unique characteristics, all of which are taken into consideration when selecting the material for a particular witch or wizard.

The length and flexibility are among the features that help define a wand and the character of its master. When Ollivander handles a pair of wands at Shell Cottage in *Harry Potter and the Deathly Hallows - Part 2*, he is able to accurately identify the wood, core, and owner of each one. The adjectives used to describe these wands could just as well apply to their masters: Draco Malfoy's wand is "reasonably pliant," while Bellatrix Lestrange's is "unyielding."

The most powerful wand in the wizarding world is the Elder Wand. According to "The Tale of the Three Brothers" in *The Tales of Beedle the Bard,* when a wizard seemingly outwits Death, he asks for the most powerful wand in existence as his reward. Death fashions him one out of an elder tree. The most difficult wand to master, the Elder Wand was for many years in the possession of Albus Dumbledore.

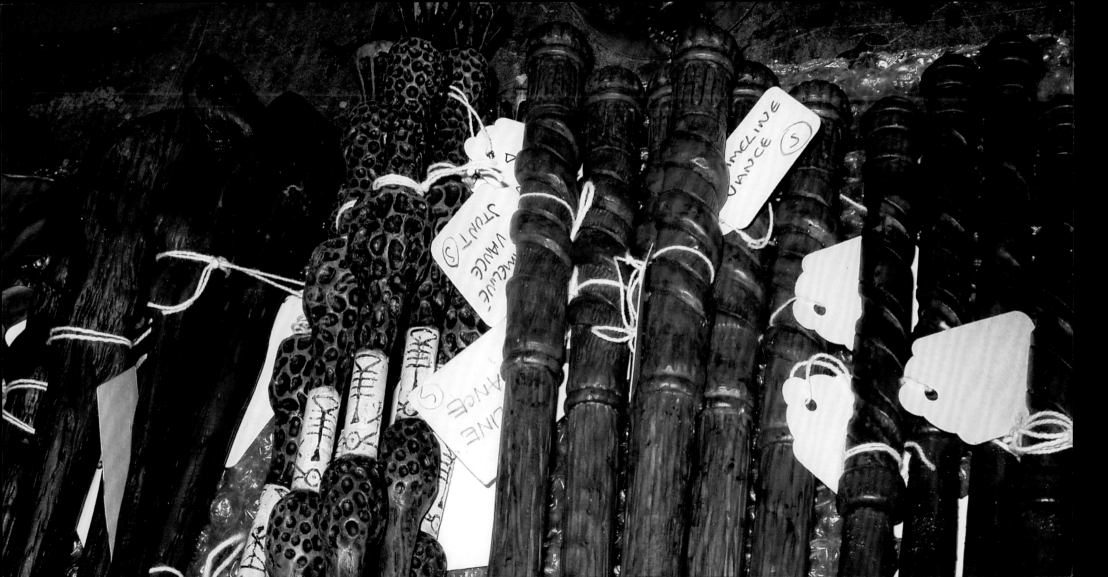

dedicated specifically to props, but the sheer volume of such items that needed to be designed from scratch was so vast the position continued throughout the entire series of Harry Potter films.

From designing to drawing to fabricating the prop and stunt wands, every wand saw multiple stages of development. Property master Barry Wilkinson, prop modeler Pierre Bohanna, and concept artists Adam Brockbank, Alex Walker, and

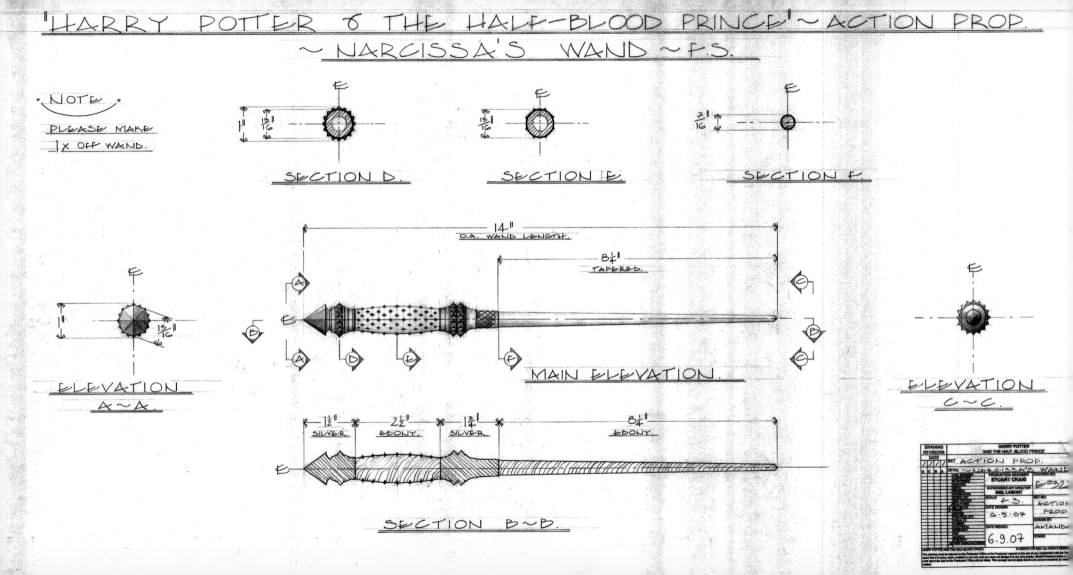

"HARRY POTTER & THE HALF-BLOOD PRINCE" ~ ACTION PROP.
~ NARCISSA'S WAND ~ F.S.

NOTE:

PLEASE MAKE
1X OFF WAND.

SECTION D.

SECTION E.

SECTION F.

$1''$ $1\frac{3}{16}$

$1\frac{3}{16}$

$\frac{7}{16}''$

$14''$
O.A. WAND LENGTH.

$8\frac{1}{4}''$
TAPERED.

MAIN ELEVATION.

ELEVATION
A~A.

$1''$ $1\frac{3}{16}''$

ELEVATION
C~C.

SECTION B~B.

$1\frac{1}{2}''$ SILVER. $2\frac{1}{2}''$ EBONY. $1\frac{3}{4}''$ SILVER. $8\frac{1}{4}''$ EBONY.

HARRY POTTER
'AND THE HALF-BLOOD PRINCE'

DRAWING REVISIONS
DATE

SET ACTION PROP.
DETAIL ~ NARCISSA'S WAND

PRODUCTION DESIGNER
STUART CRAIG
SUPERVISING ART DIRECTOR
NEIL LAMONT

DRAWING NO.
E·032

SCALE
F.S.
DATE DRAWN:
6.5.07

SET NO:
ACTION PROP

DATE ISSUED:
6.9.07

DRAWN BY:
AMANDA

STAGE

Ben Dennett, among others, all contributed to the process. The level of detail and thoughtful design is evident from the most powerful wand in the wizarding world—the Elder Wand—to the sweetest—the Licorice Wands for sale in Honeydukes candy shop.

Once the filmmakers tailored the look of each wand, supervising modeler Pierre Bohanna was tasked with creating the original, from which duplicate wands would be made for use on set. This led to the search for appropriate source materials. "We looked for interesting pieces of rare wood with burrs and interesting shapes," says Bohanna. They would then fashion molds from the specimens and make replicas out of resin and rubber to use for replacements and stunt work.

"Actual wood wands would be dangerous to use," says Bohanna. "If they fell, they'd split and shatter. Wood by its nature would be affected by heat, humidity, and cold. And it can bend, buckle, or break. So it's not a practical material to use day to day."

Garrick Ollivander of Ollivanders wand shop in Diagon Alley is widely considered the finest wandmaker in the world. It is a reputation well deserved, considering Ollivanders has been in business since 382 B.C. When it comes time to get your wand, as Hagrid tells Harry Potter in *Harry Potter and the Sorcerer's Stone,* "T'ain't no place better."

Creating the physical wizarding world and its artifacts came under the stewardship of production designer Stuart Craig. He says the character of Ollivander's shop—"dense and compact: rich in detail and modest in size"—inspired him as he created other sets for the films' dimly lit locations, such as Borgin and Burkes in Knockturn Alley. For many of these locations, the team would paint wood to give it an ebonized effect: "black paint on oak, and then rubbed back so that the grain of the wood can show through," Craig says. "The design is always an exaggeration of something identifiable. This makes the magic somehow more effective when it finally appears, whether it manifests as ghosts, wand effects, or moving staircases."

Some seventeen thousand wand boxes line the shelves of Ollivanders in Diagon Alley, recalls set decorator Stephenie McMillan. Twelve-foot-high ladders allow the proprietor to reach shelves as high as seventeen feet. Affixed onto each box is a label with wand information, including type of wood, core, and length. The detailing is spelled out in runes, scripts, and alphabets from other cultures and times. Prop artists aged the boxes with a dousing of dust to give them their essence of antiquity. Some of those wands look as if they have been waiting a very long time to find their rightful witch or wizard.

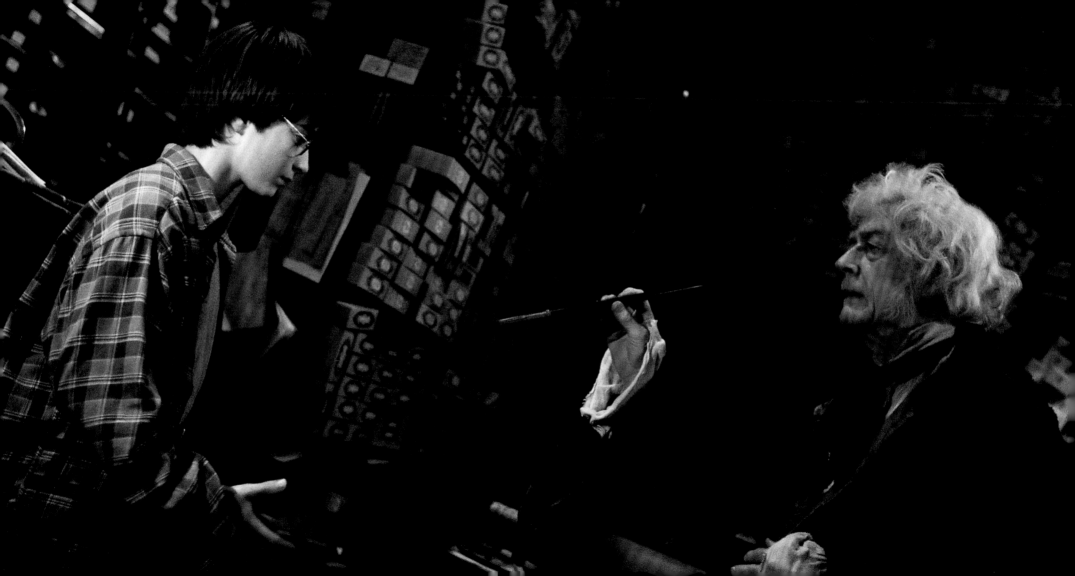

WAND SELECTION AT OLLIVANDERS

"The wand chooses the wizard, Mr. Potter. It's not always clear why."

—Ollivander, *Harry Potter and the Sorcerer's Stone*

When Harry Potter enters Ollivander's shop for the first time in *Harry Potter and the Sorcerer's Stone*, it feels as though the wandmaker was expecting him, and he reminisces over Harry's parents' first wand selections as if they happened only yesterday.

Harry doesn't know what to do with the first wand Ollivander gives him to try and holds it until Ollivander prompts him to "Give it a wave." Harry does and scores of wand boxes fly out of their drawers, emptying their contents onto the floor. Harry puts the wand down. "Apparently not," Ollivander concedes.

Harry tries a second wand and manages to shatter a flower vase, sending glass fragments everywhere. This prompts Ollivander to select a wand with a very peculiar quality . . .

When Ollivander gives Harry the third wand to try, Harry lights up with a glow as the force of the magic surges through him. Ollivander muses over this, for the wand bears the tail feather of a specific phoenix, a bird who gave just one other feather for another wand—the very wand responsible for the lightning scar on Harry's forehead.

"I think it is clear we can expect great things from you," Ollivander tells Harry. "After all, He-Who-Must-Not-Be-Named did great things. Terrible, yes. But great."

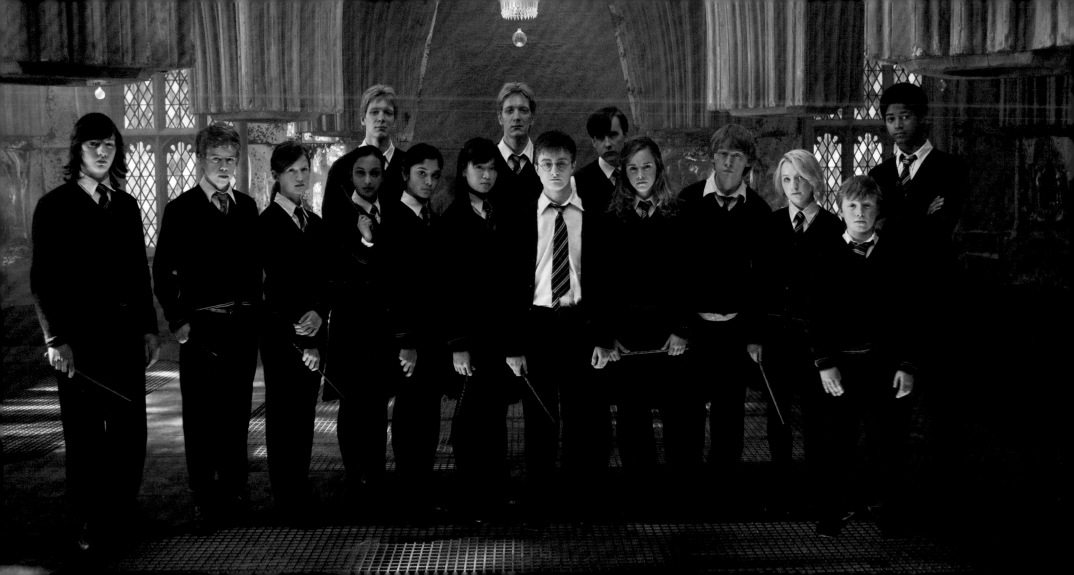

WAND MOVEMENTS AND TECHNIQUE

Lessons are essential for every witch or wizard who wishes to attain mastery of his or her instrument. As Hogwarts students learn in Professor Flitwick's Charms class, it takes a very precise "swish and flick" and reciting *Wingardium Leviosa* to make something levitate. Advanced students learn to master more particular movements to go with specific spells, such as the clockwise spin for *Reparo* or the hard right-angle flick for *Expelliarmus*.

David Yates, the director for *Harry Potter and the Order of the Phoenix* through *Harry Potter and the Deathly Hallows – Part 2*, wanted to make a distinction between how spells are performed by advanced wizards and novices. For *Order of the Phoenix*, actor Daniel Radcliffe, who plays Harry Potter, underwent movement classes to train on how to use the wand and master a particular choreography and "architecture" in terms of how to perform spells, which he admits he found quite hard at first—but really fun to do.

Actor Rupert Grint, who plays Ron Weasley, really got into the "swish and flick" choreography of the wand use. He describes the choreography developed for *Order of the Phoenix* as more combat style, with about seven different moves and spells that are "all in the wrist." It is Ron who first finds a practical use for *Wingardium Leviosa* in *Harry Potter and the Sorcerer's Stone*, when he casts the spell on a troll threatening Hermione.

When Dolores Umbridge refuses to teach proper wand usage in Defense Against the Dark Arts in *Order of the Phoenix*, students enlist Harry Potter, who has come face-to-face with Lord Voldemort, to teach them what he knows. Students line up for practical lessons in the Room of Requirement. It is here that Harry gets into the nuances of wand work. He shows Neville Longbottom that *Expelliarmus* doesn't require too much flourish, but it does require a "focus on a fixed point." Whereas, the Stunning Spell, *Stupefy*, requires more of a fast-pitch overhand flick of the wrist.

His best advice for improving wand movements: "Working hard is important, but there's something that matters even more: believing in yourself."

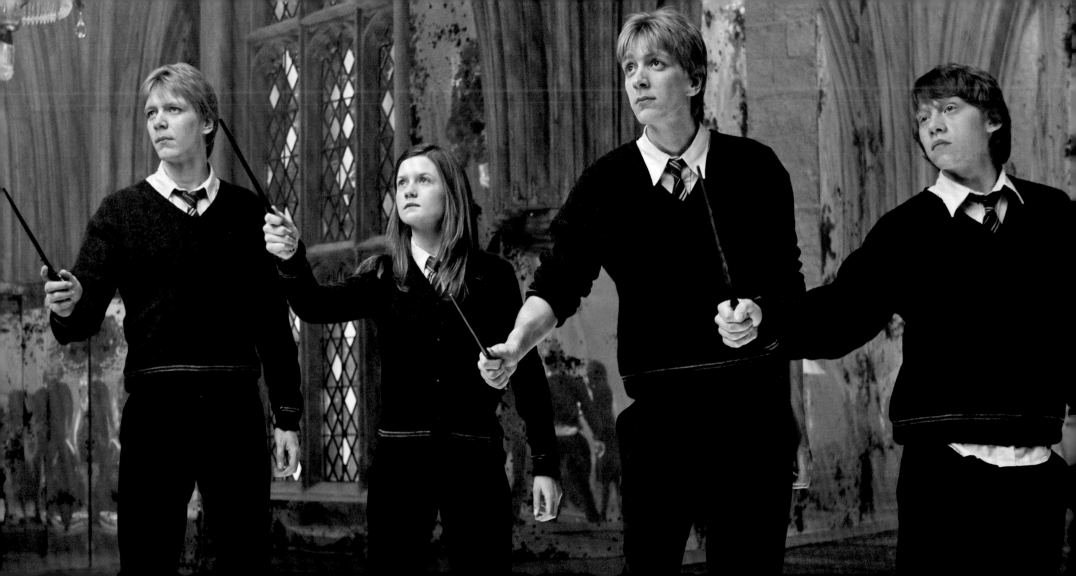

Evanna Lynch, who played Luna Lovegood, admits that she found it strange to act in battle scenes, "because she's so sort of Zen." But working with the director David Yates, she came into her fighting zone: it's when she is not worrying for her own death but the deaths of her friends. This proves most true in her formidable fight against the Death Eaters in the Hall of Prophecy in *Harry Potter and the Order of the Phoenix*.

The threatening design of Lord Voldemort's wand influenced actor Ralph Fiennes's technique. "He never holds the wand like everyone else does," observes prop maker Pierre Bohanna. "It's always at the tips of his fingers. It's a very sensitive instrument, as far as he's concerned, so he's always holding it out, and it's always above his head."

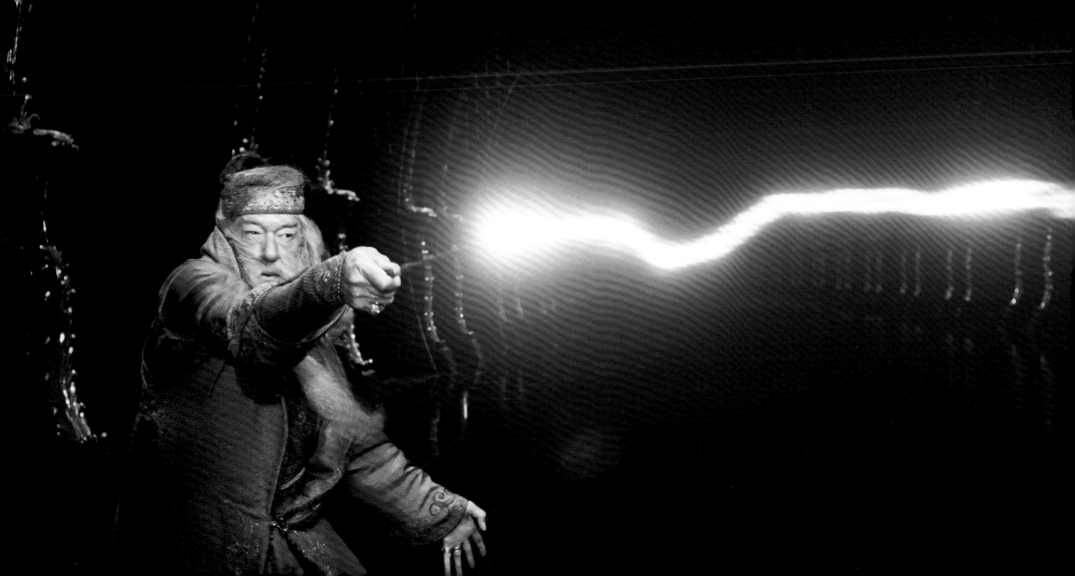

W hen wizards and witches battle, it is a confrontation like no other. The events are showdowns of experience, knowledge, character—and extreme magic. Even the most powerful wizards are put to the test, as when we see Harry Potter and Lord Voldemort duel in Little Hangleton Graveyard in *Harry Potter and the Goblet of Fire*.

The art and intensity of wand battles evolved throughout the Harry Potter films as directors Chris Columbus, Alfonso Cuarón, Mike Newell, and David Yates each contributed to the look, feel, and effect of how wizards wield their wands and work magic.

Some of the most epic wand battles came under the direction of Yates, who raised the bar for wand fighting to a level no one had seen before. *Harry Potter and the Order of the Phoenix* is the first film in which wand battles rise to an art form of their own. Yates tasked choreographer Paul Harris to come up with a set of rules of engagement for the wizards—a specific technique and mode of fighting with wands that hadn't yet been established in previous films.

"David didn't really want it to be a fight, as such," Harris recalls. "He wanted it to have the grace and movement quality that perhaps I could bring to it as a choreographer." But it was more than that. "Given that many of the spells had already been executed without action, I had to devise a set of movements from which the spells could be delivered. A generic family of positions, of movement-based positions from which the spells could be fired."

From a variety of attacking positions, the crucial element he developed with the actors was that they use their being to deliver the spell. As Harris explains, "there's the body behind it—the being, the power of the wizard—that drives every action."

When preparing for battle, Harris says it's not fighters fighting, its wizards having a fight, which is completely different. "The aesthetics of that, if you're a six hundred-year-old wizard, are completely different from a Kung Fu master in 2006. It's not the same." More so, are the wands. "It's not actually a weapon that you're striking with. There's something coming out of

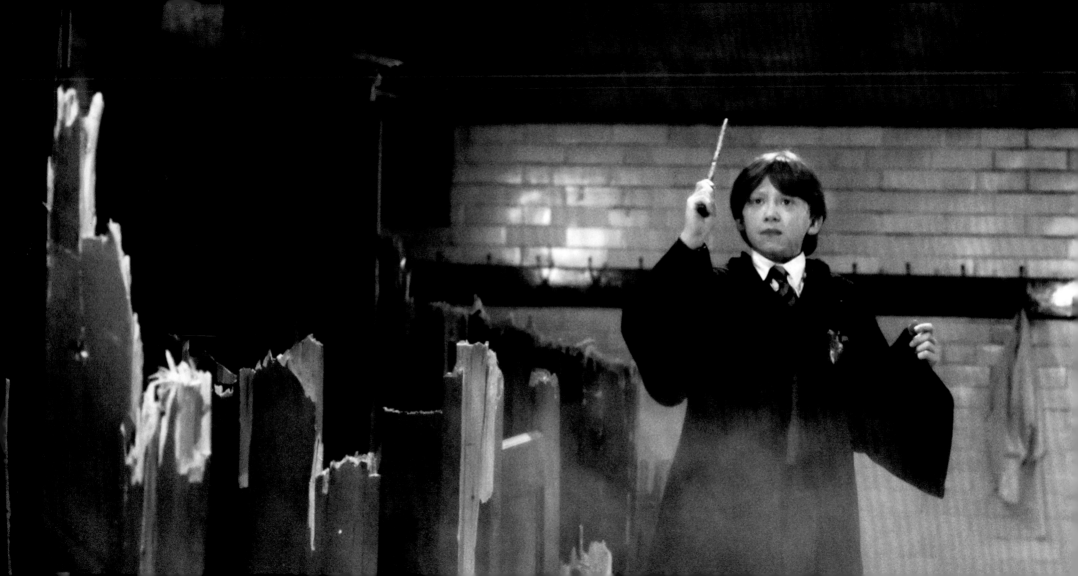

the weapon." As a result, the aim is different, and the usage of the wand is different." And, "Harris adds, "the use of the body weights are different." That was an important discovery for Harris and one of the first things he showed Yates.

As their characters learned to master proper wand movements, so did the actors who played them, learning specific actions for specific spells. "What I love most about it is that it doesn't look like anything else," says Emma Watson, who plays Hermione Granger, about the wand choreography of their first real wand fight in *Harry Potter and the Order of the Phoenix*. "It's about being with your mind, with your body. It doesn't just come from the wand, it comes from who you are." She likens it to its own art form, one that makes you "aware and impressed by what wizards are capable of doing. It's really cool."

Beyond the action of the actors, the magic display of wand power comes from the visual effects teams for the films. In *Harry Potter and the Order of the Phoenix*, the wand-to-wand combat between Voldemort and Dumbledore posed unique challenges to the creative team behind the visual effects for the film. In addition to fire and water elements, they conjured "plasma-like energy shifts that drifted a molten lava substance," says visual effects supervisor Tim Burke. To keep Voldemort suspended in Dumbledore's sphere of water, special effects supervisor John Richardson modified a green-screen broomstick rig for actor Ralph Fiennes. He also had to shatter fifty "glass" windows. It was one of those scenes that needed to work on the first take. "And I'm glad it did," says Richardson.

Stunt coordinator Greg Powell says many people were involved in the preparation of the battle scene at the Ministry of Magic in *Harry Potter and the Order of the Phoenix*. Powell recalls Yates's description of the battle as being "like World War III in there . . . but with the way wizards use their wands." Regarding the wand work in *Order of the Phoenix* alone, special effects supervisor John Richardson summed it up as: "A lot of wand spells, spell hits, people being hit by spells, things being hit and blowing up."

The
WANDS

HARRY POTTER

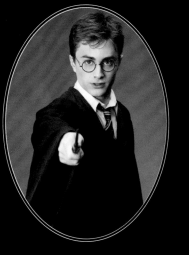

Harry Potter, famous as "The Boy Who Lived," acquires his first wand at the age of eleven during his first trip to Diagon Alley to buy school supplies before attending Hogwarts School of Witchcraft and Wizardry.

The wand that chooses Harry in Ollivander's shop is said to be of holly wood with a phoenix feather core. The wand prop seen on film is smooth and unassuming in its design.

In *Harry Potter and the Prisoner of Azkaban*, director Alfonso Cuarón offered the actors an opportunity to upgrade their wands. Actor Daniel Radcliffe chose a new wand prop with a handle retaining its outer bark, suggesting that it has been whittled from a single root or branch. It is crafted from Indian rosewood, which has a deep red color. The "bark" seen on Harry's wand was sculpted, but the carving was done on real wood. The top of the wand was cast from a tree burr. "This organic design makes it seem more mysterious and magical," says art director Hattie Storey.

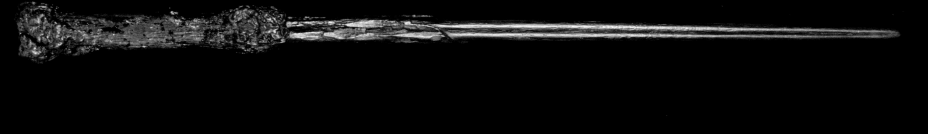

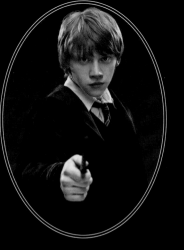

RON WEASLEY

Harry Potter's best mate and fellow Gryffindor Ron Weasley breaks his wand in *Harry Potter and the Chamber of Secrets*. The simple, baton-style wand snaps in a confrontation with the Whomping Willow on the Hogwarts grounds.

Although Ron attempts to repair his wand with Spellotape, its reliability thereafter is questionable. When Draco Malfoy calls Hermione Granger a Mudblood, Ron comes to her defense by casting a slug-vomiting spell on Malfoy. The broken wand backfires, however, leaving Ron belching up the slimy creatures himself. Actor Rupert Grint says choking up the slugs was actually his favorite scene to shoot in the film. "The slugs tasted quite nice! Chocolate, peppermint, lemon, orange . . . There were all these different flavors."

Ron remedies his wand problem by *Harry Potter and the Prisoner of Azkaban* when his parents buy him a new one. Ron's second wand bears a resemblance to Harry's with its rustic, woody design.

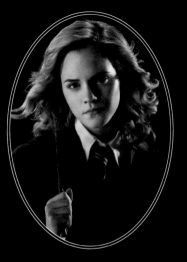

HERMIONE GRANGER

Born to Muggle parents, Hermione Granger is a first-rate witch. In love with learning, she demonstrates a most impressive acumen for spells, and best friends Harry and Ron wouldn't know what to do without her.

Hermione's wand is carved with a long tender vine wrapping around its length, revealing a smooth tip. The wand Emma Watson uses in the Harry Potter films is modeled after a hand-carved hardwood called London Plain, which was gently stained to highlight the delicate foliage wrapping.

From her first chant of *Oculus Reparo* in *Harry Potter and the Sorcerer's Stone*, when she fixes Harry's broken glasses on the Hogwarts Express, Hermione comes a long way in developing her personal wand style. In *Harry Potter and the Order of the Phoenix*, Emma worked with a choreographer to prepare for the wand battle. "That's the first time we've ever actually had to do any proper fighting with wands," she said. "It's like everything rolled into one: sword-fighting, karate, dance moves, even a bit of *The Matrix*," explains Emma of the choreography.

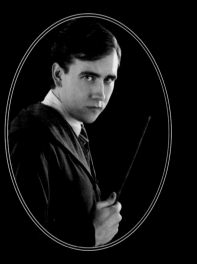

NEVILLE LONGBOTTOM

A son of respected Aurors, Neville Longbottom was sorted into Gryffindor house at Hogwarts. At first seemingly afraid of his own shadow much of the time, by *Harry Potter and the Order of the Phoenix* he is a courageous and formidable member of Dumbledore's Army.

Actor Matthew Lewis never expected his character, Neville, would fight Death Eaters as he does in the Ministry of Magic. "He's still messing up," Lewis recalls. "But he was brave enough to go out, and he raised his wand and he was fighting. It was incredible."

Neville's first, plain, wand belonged to his father and was broken in the Battle of the Department of Mysteries in *Order of the Phoenix*. His second wand is marked by its dark wood handle, which spirals into an elegant three-part twist.

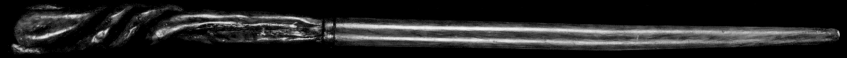

FRED WEASLEY

Fred Weasley, twin brother of George Weasley, always knew that he and his brother were destined for a future "outside the world of academic achievement."

If there are hijinks to be had, Fred and his prankster twin are guaranteed to have them—and profit. These entrepreneurial Gryffindors founded Weasleys' Wizard Wheezes in Diagon Alley.

Actor James Phelps gets a lot of laughs over the practical joker aspects of the brothers, especially on the Harry Potter film sets. "We can get away with things we wouldn't normally do and just say we're in character or something."

Fred's wand sports a long pinecone handle with a few woody nobs on its shaft.

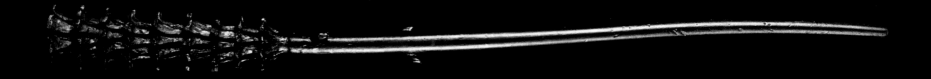

GEORGE WEASLEY

George Weasley, played by Oliver Phelps, was a natural born trickster alongside his twin brother, Fred. As a Hogwarts student, he and Fred had more fun tossing fireworks from atop their brooms than participating in O.W.L. exams.

George's wand can be seen in *Harry Potter and the Prisoner of Azakaban*, as he demonstrates for Harry how to activate the Marauder's Map with a tap of the wand and the phrase "I solemnly swear I am up to no good."

Though he may resemble his brother Fred, George's wand looks nothing at all like his twin's. The former Quidditch Beater commands a wand that is reminiscent of a broom, complete with a saddle. "The newest style broomstick!" insists Oliver Phelps of his character's wand.

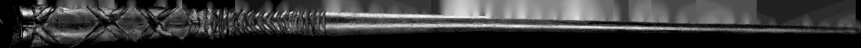

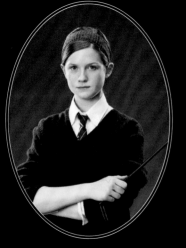

GINNY WEASLEY

The youngest of the Weasley clan, Ginny Weasley comes into her own during her time at Hogwarts and proves to be a loyal member of Dumbledore's Army. She eventually marries Harry Potter.

An agile and valiant duelist, Ginny fought several battles against Lord Voldemort's Death Eaters, including the Battle of the Department of Mysteries in *Harry Potter and the Order of the Phoenix*, which begins in the Hall of Prophecy. The force of Ginny's *Reducto* Curse shatters the vault of its stored prophecies.

Ginny's all black wand has a swirl in the handle, leading into a décor of raised crosshatching that separates the handle from the shaft.

Bonnie Wright, who plays Ginny, especially enjoyed observing the unique wand styles displayed by the actors during filming. "Obviously, everyone holds their pen differently, so it's kind of the same in the way you hold your wand."

DRACO MALFOY

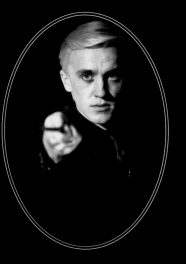

A Slytherin and pure-blood son of a Death Eater, Draco Malfoy uses a wand with a core of unicorn hair.

In *Harry Potter and the Goblet of Fire*, Draco's wand-wielding catches the discerning eye of Professor Mad-Eye Moody, who doesn't take kindly to back shooters. When Draco points his wand tip at the back of Harry's head, quick-draw Moody blasts Draco with a Transfiguration Spell, changing Malfoy into a ferret before he can successfully catch Harry off guard.

Actor Tom Felton recalls filming his wand battle against Harry Potter in the bathroom for *Harry Potter and the Half-Blood Prince*. "It was really nice for us, actually, because the entire bathroom was rigged with explosives, so that any time we waved our wands at each other something blew up."

Draco Malfoy's blunt-tipped wand shaft is crafted out of light-brown Mexican rosewood, attached to a jet-black ebony handle. After Harry takes Draco's wand from him in *Harry Potter and the Deathly Hallows – Part 1*, Draco borrows his mother's wand. Narcissa Malfoy's silver-studded wand is wielded by her son during the skirmish in the Room of Requirement in the final film.

LUNA LOVEGOOD

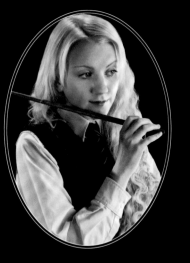

Luna Lovegood's first wand is baton style, engraved with a vine twisting among acorns. But when this Ravenclaw loses her wand to Death Eaters in *Harry Potter and the Deathly Hallows – Part 2*, it's reasoned that Ollivander, who is imprisoned in Malfoy Manor with her, fashions her a new one. Her second wand is of darker wood, with a handle that resembles a long, flowering tulip.

Actor Evanna Lynch confesses, "I was a bit disappointed," when, on the set of *Harry Potter and the Order of the Phoenix*, she recited the incantation *Expecto Patronum* and nothing came out of her wand. Evanna had to picture herself producing the hare Patronus from the tip of her wand, seen by viewers thanks to the visual effects in the final film. "You have to imagine so much!" notes Evanna. "It's actually quite hard."

Luna becomes a key member of Dumbledore's Army and can be seen wielding her first wand in the Battle of the Department of Mysteries when she sends a masked Death Eater flying by chanting *Levicorpus*.

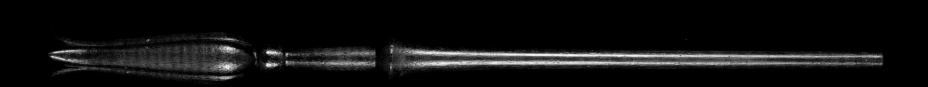

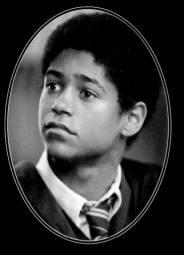

DEAN THOMAS

A half-blood wizard, Dean Thomas is a Chaser for the Gryffindor Quidditch team in his sixth year. A member of Dumbledore's Army, he briefly dated Ginny Weasley and fought in the Battle of Hogwarts in the final film.

"If I could cast any spell . . ." muses actor Alfred Enoch, who plays Dean, "where does it stop? . . . You could do just about anything. It would be great."

Dean wields a spare, dark brown hardwood baton for a wand with a distinctive branch snaking two roots around the end for a handle.

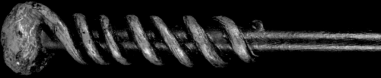

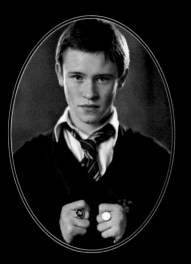

SEAMUS FINNIGAN

Seamus Finnigan is an Irish, half-blood wizard and member of Dumbledore's Army. "Me dad's a Muggle, mam's a witch," he explains in *Harry Potter and the Sorcerer's Stone*. "Bit of a nasty shock for him when he found out."

Seamus has a "particular proclivity for pyrotechnics," notes Professor McGonagall, who enlists him to blow up the wooden bridge prior to the Battle of Hogwarts. He manages to explode his feather in Professor Flitwick's *Wingardium Leviosa* lesson in *Harry Potter and the Sorcerer's Stone*, and his attempt to brew a draught of Living Death in Professor Slughorn's Potions class in *Harry Potter and the Half-Blood Prince* has a similar end.

"I'm definitely like Seamus in real life, I'm clumsy," says actor Devon Murray. There are wand statistics to confirm it: Murray held the record on set for the most prop wands broken during the course of filming a single scene: ten.

Seamus's baton-style wand is a ruddy brown, marked by a black-spiraled handle.

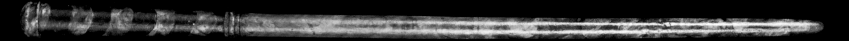

VINCENT CRABBE

The son of a Death Eater, Vincent Crabbe is among the Slytherin set led by Draco Malfoy.

Crabbe's wand is a thick light hawthorn wood to its flat blunt end, lathed with curves to show the darker layers of rings underneath.

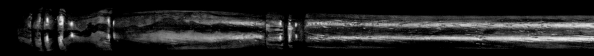

GREGORY GOYLE

Gregory Goyle of Slytherin house chummed up with fellow wizards whose fathers were also Death Eaters, namely Vincent Crabbe and Draco Malfoy.

When he fights alongside Draco Malfoy in the Room of Requirement during the Battle of Hogwarts in *Harry Potter and the Deathly Hallows – Part 2*, Goyle can't control the Fiendfyre coming from his wand and eventually chucks it into the spreading flames.

Goyle's wand is two-toned light and dark wood. Its handle is largely lighter wood offsetting the length of the dark, flat-topped shaft.

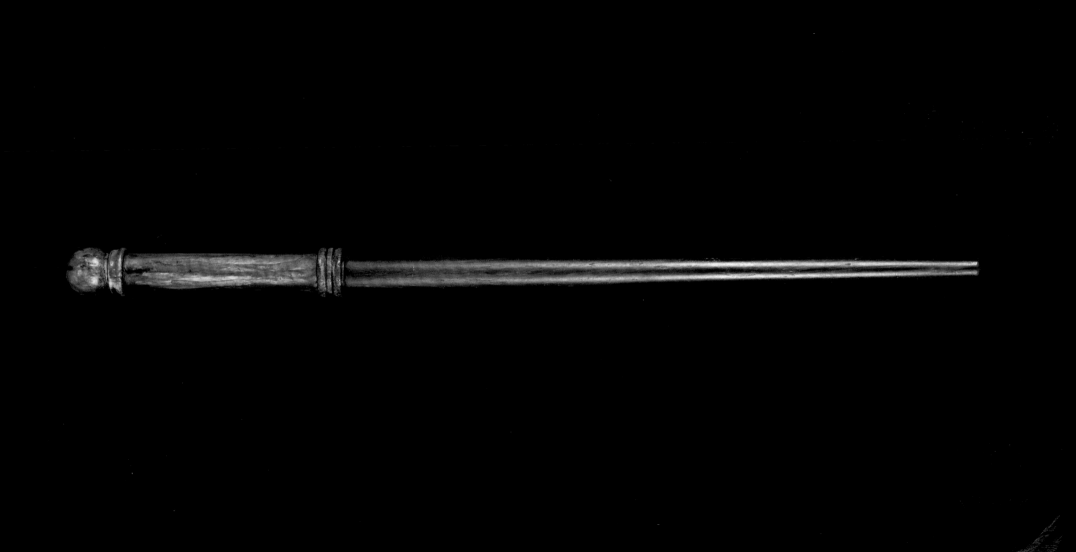

CHO CHANG

A member of Ravenclaw house, Cho Chang dedicated herself to the fight against Lord Voldemort when he murdered her boyfriend, Triwizard champion Cedric Diggory.

As a member of Dumbledore's Army, Cho is "very determined to be taught all this magic," says Katie Leung, who plays Cho. "She wants to avenge Cedric's death." She proves her wand-worthiness in the final battle against the Death Eaters as part of the attack force for Hogwarts in *Harry Potter and the Deathly Hallows – Part 2*.

Cho's wand is a rich reddish brown wood with a smooth rustic handle that has been fashioned with a swirl. The shaft is etched with fossils of leaves that diminish into a single thread that twirls toward the tip.

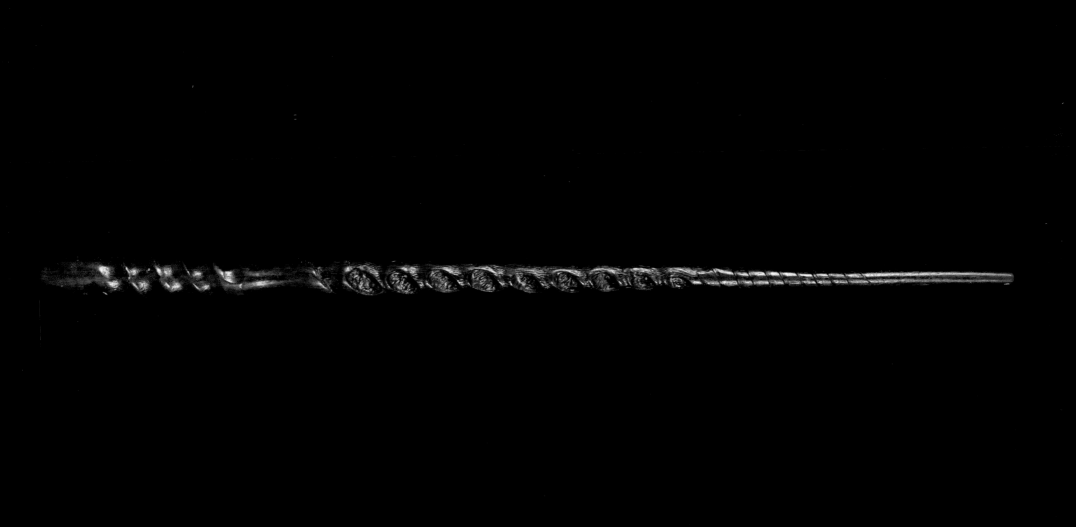

PARVATI PATIL

Sorted into Gryffindor, Hogwarts student Parvati Patil is Harry Potter's date for the Yule Ball in *Harry Potter and the Goblet of Fire* and, along with her sister Padma, an active member of Dumbledore's Army.

It is in Professor Lupin's lesson on Boggarts in *Harry Potter and the Prisoner of Azkaban* that Parvati masters the *Riddikulus* Spell against her worst fear: a snake.

Parvati's wand is a warm-toned wood with a raptor-like wrap that resembles the edge of a dragon's wing around the handle.

PADMA PATIL

Parvati's sister, Padma is a member of Dumbledore's Army and, at least in the film series, of Gryffindor house. Padma was Ron Weasley's date for the Yule Ball in *Harry Potter and the Goblet of Fire*, though she abandons Ron after he refuses to ask her to dance.

In *Harry Potter and the Order of the Phoenix*, Padma uses her wand to set a paper swallow flying in Dolores Umbridge's Defense Against the Dark Arts classroom. The bird is incinerated by Umbridge, establishing a punishing tone for the class.

Padma Patil's wand is a simple baton style, engraved with runes and circular symbols.

CORMAC McLAGGEN

A member of Gryffindor house and Professor Slughorn's Slug Club, Cormac tries out for Keeper of the Gryffindor Quidditch team in *Harry Potter and the Half-Blood Prince*, but loses out to Ron after being hit by Hermione's Confundus Charm. Later, Cormac is Hermione's date to the Slug Club Christmas party, but she isn't exactly fond of him. "Hermione essentially just uses Cormac," explains Emma Watson.

Cormac McLaggen's wand features a mahogany-colored spiral along its handle and is carved from tip to tip in order to draw attention to its woody grain.

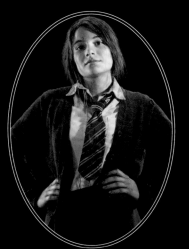

KATIE BELL

Katie Bell is a member of the Gryffindor Quidditch team and Dumbledore's Army. In *Harry Potter and the Half-Blood Prince*, she is cursed by an opal necklace sent by Draco Malfoy and intended for Professor Dumbledore.

Katie Bell's wand is quite short and features a subtle design resembling a branch that has been slowly rubbed smooth.

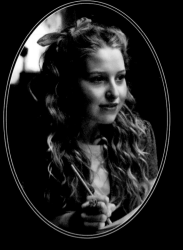

LAVENDER BROWN

Lavender Brown is a member of Gryffindor house and Dumbledore's Army. In *Harry Potter and the Half-Blood Prince*, she falls headfirst into a relationship with Ron Weasley, referring to him as "Won-Won."

Lavender fights bravely in the Battle of Hogwarts in *Harry Potter and the Deathly Hallows – Part 2*, but is killed by the werewolf Fenrir Greyback. When Harry, Ron, and Hermione come upon Greyback savaging the lifeless Lavender Brown, Hermione sends the werewolf flying with a flash of her wand.

"She is very bubbly, she likes pink," notes actress Jessie Cave of her character. "I'd like to think she'd have a poodle or something." Lavender's wand is much more subtle and unassuming than you'd expect given her personality. The baton-style wand features a curved black line toward its base and a series of rings that separates the brown handle from the wand's mahogany-colored tip.

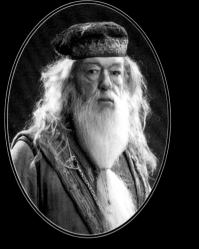

PROFESSOR DUMBLEDORE

One of the most formidable wizards of his time, Albus Dumbledore is best known as Headmaster of Hogwarts School for Witchcraft and Wizardry and founding leader of the Order of the Phoenix. Professor Dumbledore's wand is the most powerful in existence—the Elder Wand—which he obtained upon defeating its former master in a duel.

Actor Sir Michael Gambon loves how Dumbledore can use his wand to pull memories out of his head in the form of long silvery-gold streams and store them away in his Pensieve. "I wish I had one at home," says Gambon.

Albus Dumbledore's onscreen Elder Wand is crafted from English oak with "wonderful outcroppings of nodules," explains prop maker Pierre Bohanna. It is inlaid with bone and etched with runes. It is thin and distinctive, easily recognizable from afar.

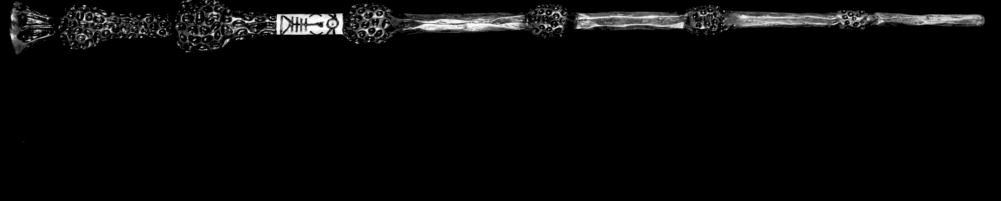

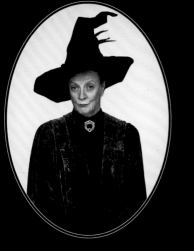

PROFESSOR McGONAGALL

Transfiguration professor and Head of Gryffindor house, Minerva McGonagall is a known Animagus, a person who can turn into an animal at will. She's first seen transforming from her tabby cat form into her human form in *Harry Potter and the Sorcerer's Stone*.

"The magic never goes," says Dame Maggie Smith, who plays McGonagall. "I remember walking into the Great Hall for the first time and not believing it, it was so amazing," she says. "It still has that effect on me." In preparation for her wand battle against Severus Snape in *Harry Potter and the Deathly Hallows – Part 2*, Smith and Snape actor Alan Rickman had several rehearsals. "We used our wands almost like foils," she notes, referencing the sensitive weapons used in the sport of fencing, "But, until I see the film, I don't know what magic will come out of the ends of them."

Professor McGonagall's sleek, black-tipped wand exemplifies her no-nonsense sensibility. The handle has a Victorian-style curvature tipped with an amber stone.

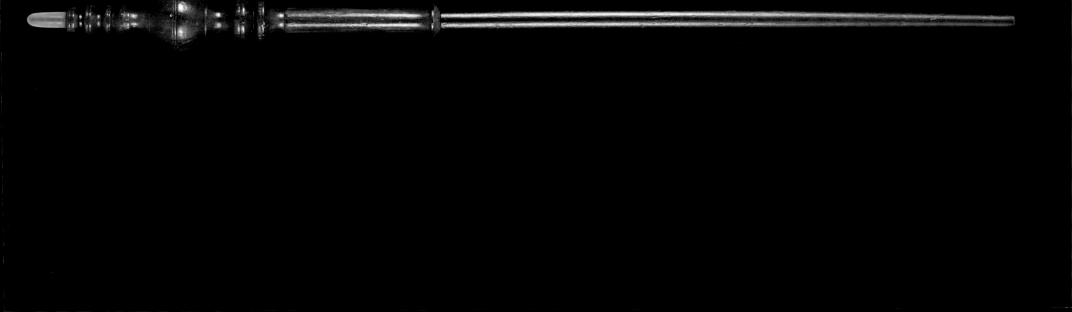

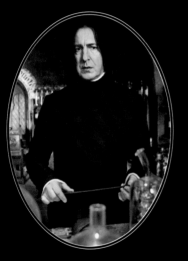

PROFESSOR SNAPE

The Head of Slytherin house and Potions master, Professor Severus Snape was the "Half-Blood Prince" who developed a penchant for the Dark Arts as a young wizard.

With the use of his wand, Snape devised his own spells, including the *Sectumsempra* Curse, which Harry Potter uses in the sixth film to release a flash of white light from the tip of his wand and slice the flesh of Draco Malfoy. As skillful as Snape was in the Dark Arts, he was equally so in defending against them. His chant of *Vipera Evanesca* eradicates the serpent Draco Malfoy conjures in a duel against Harry Potter in *Harry Potter and the Chamber of Secrets*.

The late Alan Rickman, who portrays Snape, once explained what it felt like dueling against Professor McGonagall in *Harry Potter and the Deathly Hallows – Part 2*: "Holding a wand isn't the most threatening thing you can do, and pointing it at Dame Maggie Smith, who you've grown up worshipping from the cheap seats at the National Theatre . . . and she's pointing it at you. And she can arch an eyebrow like nobody, so thank God for the sheets of flame."

Severus Snape's wand is spare, black, and confined, reflecting the way the character prefers to carry himself. An intricately carved design marks the handle of his wand, complementing the mysterious complexity of its master.

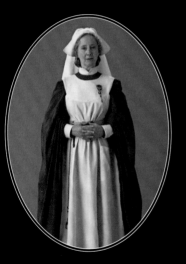

MADAM POMFREY

Hogwarts hospital matron, Madam Poppy Pomfrey, carries a wand as practical as she is, fashioned of hard, dark wood with an unknown core. Its knobbed handle resembles that of a simple bedpost.

Madam Pomfrey's expertise is magical medicine, but not everything is possible with a mere incantation. "I can mend bones in a heartbeat," she tells Harry when Professor Lockhart's botched *Brackium Emendo* Spell renders his arm boneless after a Quidditch mishap in *Harry Potter and the Chamber of Secrets*. But "regrowing bones is nasty business."

Pomfrey works her wand to maim as well as heal, as she successfully fights off at least one Death Eater during the Battle of Hogwarts.

The wand battles were "a bit tame" at first, confesses actress Gemma Jones, who portrays Pomfrey. "But when everything's put on in special effects, with sparks and flashes coming out of our wands, you realize how powerful you are."

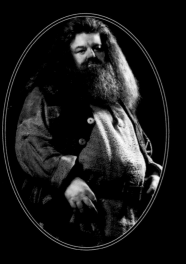

RUBEUS HAGRID

The Keeper of Keys and Grounds of Hogwarts is a job for none other than Rubeus Hagrid, an eight-foot-six, half-giant wizard whose ability to handle even the fiercest of creatures lands him the position of Care of Magical Creatures professor in Harry Potter's third year.

Hagrid was expelled from Hogwarts as a student and is not supposed to use his wand. However he does carry a pink umbrella that has been seen to do magic, implying that shards of his original wand are cleverly concealed inside.

Not the best one to follow rules, Hagrid attempts to teach Harry's greedy Muggle cousin, Dudley, a lesson by causing him to sprout the tail of a pig in *Harry Potter and the Sorcerer's Stone*.

Robbie Coltrane describes his character, Hagrid, as like "the unmarried uncle who lives in a rather cool pad." The prop department and the art department provided him with his umbrella and other personal effects, including the sundries in his hut. "They've done fantastic stuff," he says.

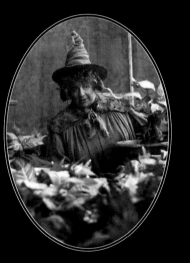

PROFESSOR SPROUT

Herbology professor and Head of Hufflepuff house, Pomona Sprout wields a wand that might easily be mistaken for a grainy stick from a tree branch found in the garden.

Sprout puts her magical plant skills to work against Dark Magic by cultivating Mandrakes for their ability to counter the Petrification of students and others caused by a Basilisk in *Harry Potter and the Chamber of Secrets*. When she does take up her wand, it is in devotion to her beloved institution, as she does during the Battle of Hogwarts.

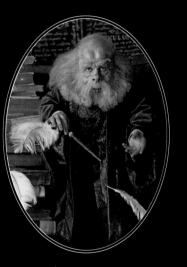

PROFESSOR FLITWICK

Charms professor and Head of Ravenclaw house, Filius Flitwick wields a wand that has a seamless flow from handle to tip. During his Charms lesson in *Harry Potter and the Sorcerer's Stone*, the distinctive wand can be seen with its ivory-like ball at the pommel and Celtic knot carvings on the shaft.

Flitwick's wand was updated along with his costume and look for *Harry Potter and the Goblet of Fire*, where actor Warwick Davis appears as choirmaster. The new wand is seemingly fashioned out of one single piece of wood, from its darkened tip to its lighter end, which separates into four rounded parts, as the silhouette of a bird or a butterfly.

Actor Warwick Davis confesses that his absolute favorite thing to say as Flitwick is *Wingardium Leviosa*, when he demonstrates the Levitation Charm to first-year Charms class students. Davis admits he got quite carried away conducting when he wielded his wand before the Frog Choir. He finds the sets and props "so real and so wonderfully detailed that you really can immerse yourself in the wizarding world."

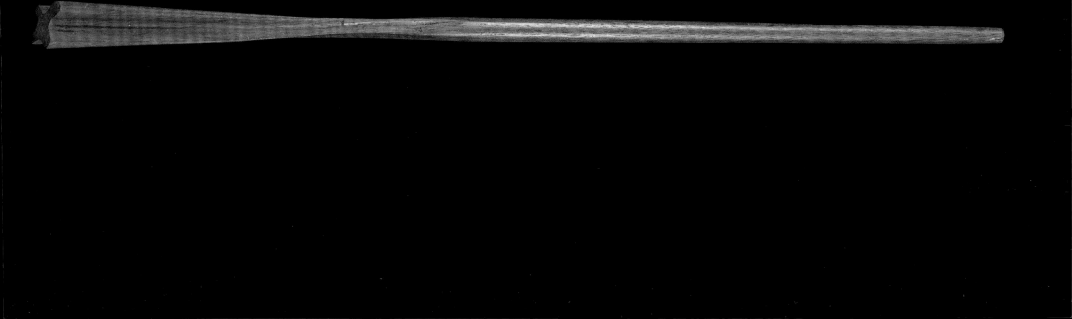

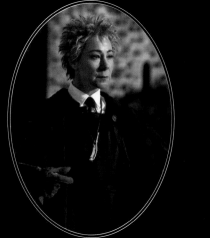

MADAM HOOCH

Flight instructor and Quidditch referee Madam Hooch is well known among Hogwarts first-year students as the master of proper form and technique for mounting and flying brooms. "Brush backward, of course," says actress Zoë Wanamaker, who plays Hooch, "otherwise you'll go backward."

 Hooch is quick with her wand to try to help Neville Longbottom when he can't control his broom during their first flying lesson in *Harry Potter and the Sorcerer's Stone*, but unfortunately, he falls to the ground before she can speak an incantation.

 Fitting for a referee, Madam Hooch's wand has something of a neutral baton design.

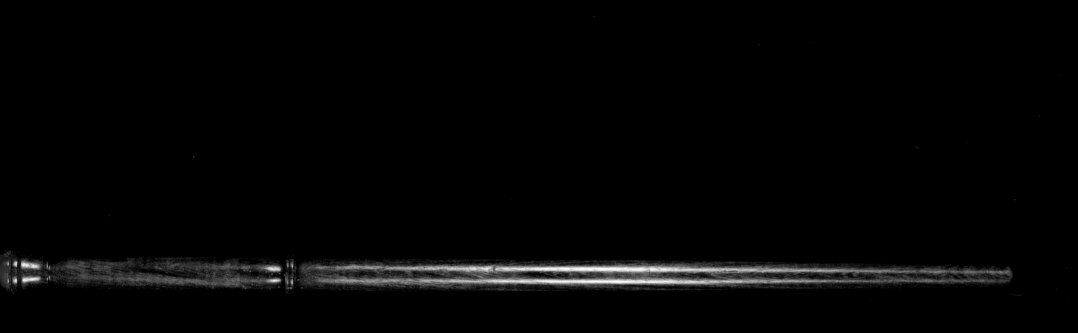

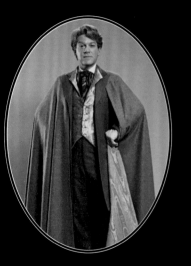

PROFESSOR LOCKHART

Gilderoy Lockhart is a dandy of a professor but a disaster of a Defense Against the Dark Arts instructor. "He's the kind of guy that, if you've been to the moon, he's been there twice," says actor Sir Kenneth Branagh of his braggart character. Producer David Heyman says Branagh "embraced the narcissism full-heartedly."

The wand used by Branagh in *Harry Potter and the Chamber of Secrets* is a good fit for Lockhart's showy personality. Though most of the wands for the first two Harry Potter films were very simple, Professor Lockhart's is adorned with an elegant lily pommel at the top of its handle.

The wand suggests an elegance that does not quite match its performance—or that of its performer. When Lockhart tries to stop a cage of Cornish pixies from wreaking havoc in his classroom by chanting *Peskipiksi Pesternomi,* he only succeeds in losing his wand to one of the creatures. His Memory Charm works wonders however. When he seizes Ron Weasley's broken wand in the Chamber of Secrets, his incantation of *Obliviate* backfires onto himself by virtue of the defective wand, wiping out all the professor's memories.

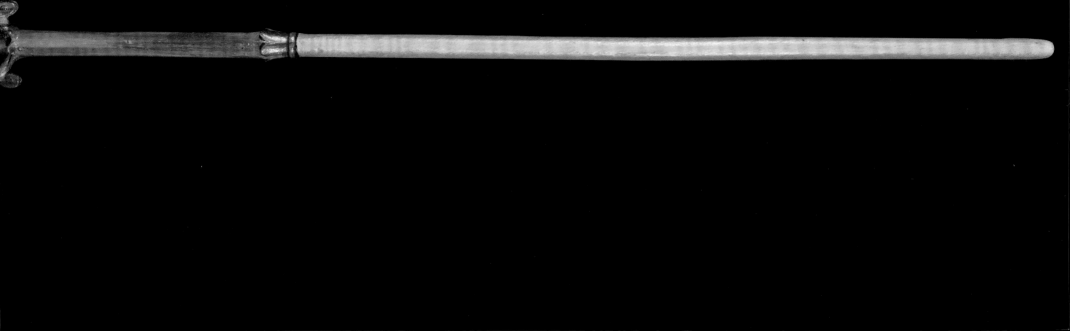

PROFESSOR LUPIN

Harry Potter's third year Defense Against the Dark Arts professor, Remus Lupin, has a dark side himself, as he struggles with the duality of being a werewolf.

In *Harry Potter and the Prisoner of Azkaban*, Lupin is quick with his wand against a Dementor that boards the Hogwarts Express in search of Sirius Black. Later, while teaching Harry's class to defend themselves against Boggarts, he intercepts Harry's Dementor Boggart with his own full moon Boggart, which turns into a balloon with the *Riddikulus* Spell.

In learning to fight like a wizard, actor David Thewlis spoke of his experience as Professor Lupin as "trying to make a wand feel like an AK-47."

The wand Thewlis uses onscreen is carved out of olivewood, with a balled, moonlike handle that gently twists into a straight baton point.

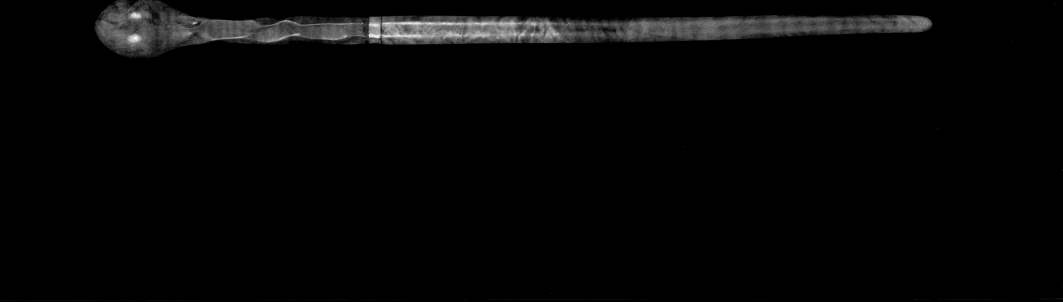

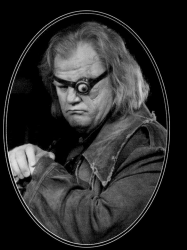

PROFESSOR MOODY

Ex-Auror and Order of the Phoenix member Alastor "Mad-Eye" Moody comes to Hogwarts to teach Defense Against the Dark Arts in *Harry Potter and the Goblet of Fire*. Moody is "a gunslinger with a wand," as Brendan Gleeson likens his character. After all, he's responsible for sending more than half of the Death Eaters to Azkaban prison.

Moody actually kept more than one wand, including a silver one dedicated to the repair of his prosthetic leg. The dark red wood of the wand Moody uses predominantly is most visible in its rounded handle. Smoothed of its outer bark, the handle has a natural pock, a socket to match Mad-Eye himself.

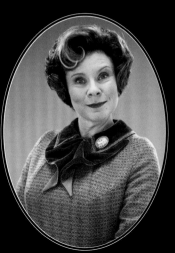

PROFESSOR UMBRIDGE

Never without her signature pink, from her lipstick to her shoes, Professor Dolores Umbridge is a proud Senior Undersecretary to the Minister for Magic, Hogwarts Defense Against the Dark Arts professor, High Inquisitor, and Headmistress, first seen in *Harry Potter and the Order of the Phoenix*.

She appears soft yet is fierce to the core. Actress Imelda Staunton describes her as someone with "little power . . . but she will hang on to it."

Though she scolded her students for their wand use, she has no problem threatening Harry with the *Cruciatus* Curse in *Order of the Phoenix*.

Fit to her stature, Umbridge's wand is remarkably short. Its dark wood is fashioned into a tight stacking of concentric rings, punctuated with a pink gemstone in the center.

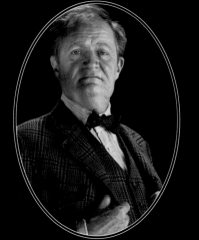

PROFESSOR SLUGHORN

Horace Slughorn comes to Hogwarts to fill the post of Potions master in *Harry Potter and the Half-Blood Prince*, during the year Professor Snape finally becomes the Defense Against the Dark Arts professor. Slughorn has a certain penchant for "collecting" students of renown and wants Harry Potter to become his latest acquisition.

 The double curve in the length of Professor Slughorn's wand evokes a slug on the move. The tip of his wand "has two little antennae, like a slug or a snail," says art director Hattie Storey. Metal inlay gives the handle the sheen of gunmetal silver, with a design that mimics the trail of a gastropod.

 "It's a fantastic job," says Slughorn actor Jim Broadbent. "Every detail of it, all the props and the furniture and everything is absolutely perfect."

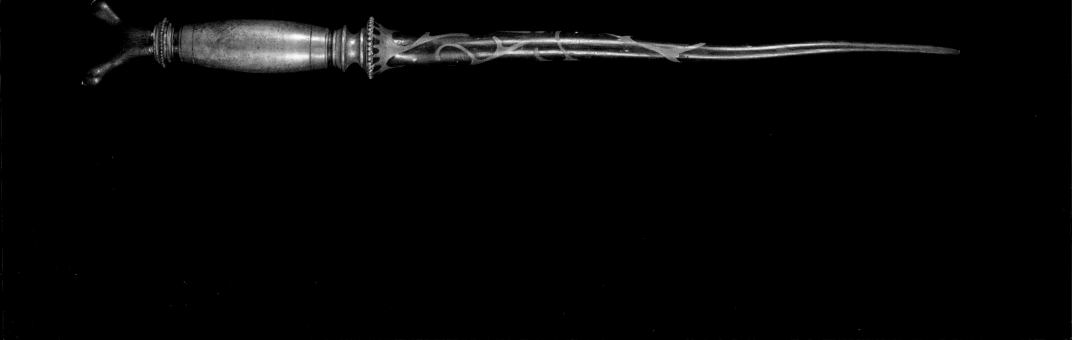

PROFESSOR TRELAWNEY

As Harry Potter learns in *Harry Potter and the Order of the Phoenix*, it is Sybill Trelawney who foretold of the boy with the power to defeat the Dark Lord.

Costume designer Jany Temime worked closely with actress Emma Thompson to perfect the look of her attire, made of material decorated with little mirrors. "I've got eyes all over my costume," says Emma—a fitting design for someone who tries to see into the future.

Trelawney's wand looks like a cross between a hairpin and an eating utensil. A carved spiral emanates from the tip into a square handle inscribed with runes and symbols that refer to celestial bodies.

When it comes to learning how to use magic, Thompson compared it to learning how to do housework: "The practicality of it is the fact that it's every day and you just need to learn how to do these things, and it's obvious, and let's get on with it."

CEDRIC DIGGORY

Triwizard Tournament champion Cedric Diggory was a Hufflepuff Prefect, distinguished Seeker, and Quidditch team captain.

Actor Robert Pattinson states that a favorite scene during *Harry Potter and the Goblet of Fire* was during the third task of the Triwizard Tournament in which Viktor Krum is under the *Imperius* Curse and attacks Cedric when Harry's in the middle of the crossfire. "And we're both screaming at each other . . . telling Harry to get down, and Krum's screaming in Bulgarian, sort of—I don't know what he's screaming about."

Cedric's wand is a black-tipped baton style. Made from the same mold as Padma Patil's wand but lighter in color, it is etched with wheel-like designs and alchemical symbols on its handle.

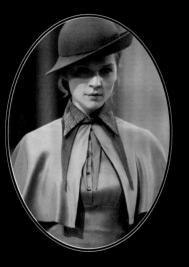

FLEUR DELACOUR

Beauxbatons Academy of Magic student Fleur Delacour is the Triwizard Tournament champion of her school. Beauxbatons wands come out in grand style among the chic French boarding school girls. And like the uniforms worn by the girls who wield them, Beauxbatons wands are topped with a tasteful flourish.

Fleur's wand is as elegant and graceful as she is. The handle curves with a flourishing spiral. A luxurious leaf wraps itself along the length of the tapering wand, suggestive of the edge of a petticoat or parasol.

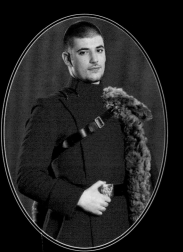

VIKTOR KRUM

Durmstrang Institute student and Bulgarian National Quidditch Team Seeker, Viktor Krum is the Triwizard Tournament champion for his wizarding school. The Durmstrang Institute is known as one of the leading schools for magic in all of Europe, set in the northern realm of the continent. Producer David Heyman talks about the fierce, cool attitude of the Durmstrang boys: "They're quite austere and intimidating." And so are their wands.

Viktor carries a wand whose handle resembles a bird's head, a nod to the eagle symbol of the Durmstrang Institute. It is thick and roughly cut, with a natural curve.

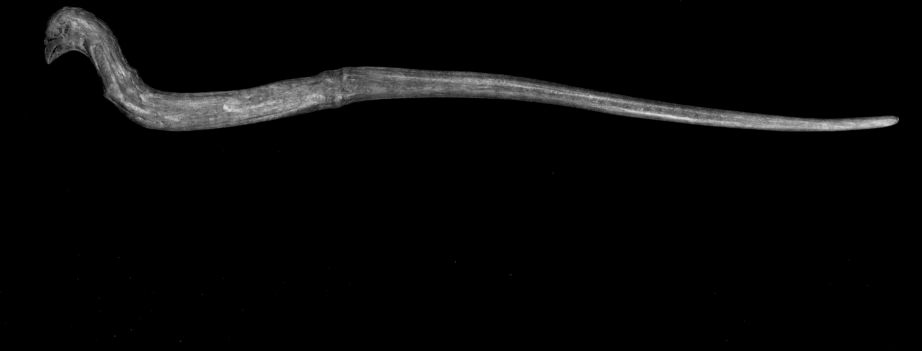

SIRIUS BLACK

Wrongfully imprisoned in Azkaban for the murder of Peter Pettigrew and twelve Muggles, Sirius Black is the godfather of Harry Potter.

Executive producer David Barron agrees with Sirius's warning to Harry: "We've all got both light and dark inside us. What matters is the part we choose to act on." In the Battle of the Department of Mysteries in *Harry Potter and the Order of the Phoenix*, Sirius wields his wand for good in a fatal fight, where Bellatrix Lestrange uses the Killing Curse on him.

Gary Oldman, who plays Sirius, enjoyed working with Paul Harris on wand choreography for the fight in the Death Chamber. "There are certain ways of using the wand, certain movements, a certain physicality. One spell may be above the head, another spell may be from down below. In action, [the wand is used] aggressively, and quite violently, really."

Sirius's wand tapers from a square handle into a length engraved with a trail of circles and dots along the shaft. The runic symbols along the flattened ends complement the tattoos that ink his body.

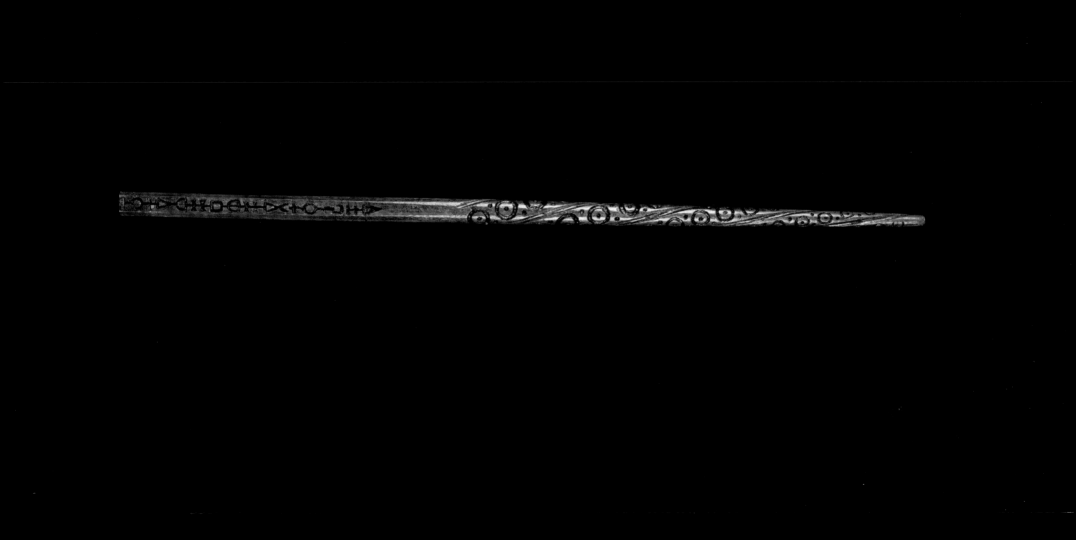

NYMPHADORA TONKS

Nymphadora Tonks is a an Auror, Metamorphmagus, and the wife of Remus Lupin, a known lycanthrope.

Actress Natalia Tena tried to incorporate a dance element in her wand style. However, her character is not known for her physical poise. "So I do this massive spell, and when I landed I meant to be like a ballerina—very graceful. And then I trip up. So, Tonks's style is that she is very good, but she just can't help getting it wrong."

As a member of the Order of the Phoenix, Tonks fought bravely against Voldemort's Death Eaters in the Battle of the Department of Mysteries in *Harry Potter and the Order of the Phoenix*, and again in the Battle of Hogwarts in the final film, which, sadly, led to her death.

Tonks's wand is carved of two different woods, with a striped shaft that opens into a jack-in-the-pulpit flower. Tena confesses it wasn't until filming *Harry Potter and the Deathly Hallows – Part 1* that she learned how to truly hold her wand upon discovering "a little nook to work with!"

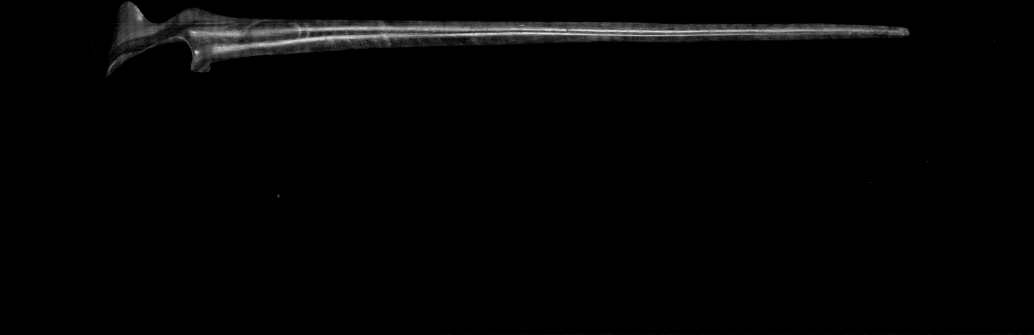

KINGSLEY SHACKLEBOLT

Kingsley Shacklebolt is an esteemed Auror and member of the Order of the Phoenix. When the Ministry of Magic falls to Death Eaters in *Harry Potter and the Deathly Hallows - Part 1*, Shacklebolt sends his lynx Patronus to The Burrow to alert the guests at Bill and Fleur's wedding.

Actor George Harris describes Shacklebolt as someone who "has a quiet strength and wants to keep a lid on it." It is fitting that his wand suggests the same quiet strength with its multiple layers of wood, and elegant, definitive carvings. Yet when it comes to the Battle of the Department of Mysteries in *Harry Potter and the Order of the Phoenix*, Harris says, "I can't wait to get my wand out."

The Auror's wand has a handle that is suggestive of a germinating plant.

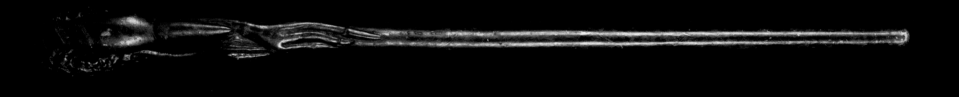

MUNDUNGUS FLETCHER

Mundungus Fletcher is among the Order of the Phoenix members who arrive at number four, Privet Drive to escort Harry from the house in *Harry Potter and the Deathly Hallows – Part 1*. Unlike everyone else, Mundungus's participation in the operation isn't exactly voluntary. "Technically, I've been coerced," he explains.

Later in the film, when Kreacher and Dobby bring him into 12 Grimmauld Place, Mundungus claims to be a "purveyor of rare and wondrous objects." Ron disagrees. "You're a thief, Dung, everyone knows it," he says. When he tries to whip out his wand in the Grimmauld Place kitchen, Mundungus is promptly disarmed by Hermione.

Fitting for a man who will go to great lengths to get his hands on valuable items, Mundungus Fletcher's wand features a golden knot set above the handle, reminiscent of a ring gemmed with a large black stone. At the base of the wand is a golden icon resembling a lion.

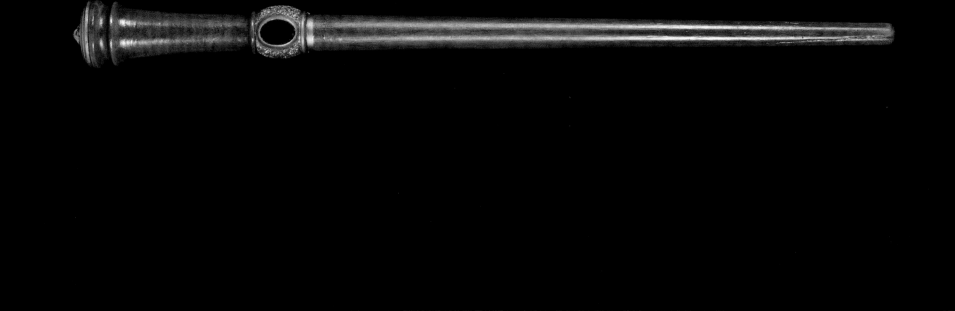

LORD VOLDEMORT

Tom Riddle, a half-blood wizard and member of Slytherin house at Hogwarts, became obsessed with the Dark Arts and a desire to achieve immortality while still a youth. He eventually abandoned his Muggle-born identity and took on the name Lord Voldemort. He is considered by many to be the most dangerous and powerful wizard in the wizarding world.

In *Harry Potter and the Order of the Phoenix*, choreographer Paul Harris developed specific wand movements for the powerful exchanges between Voldemort and Dumbledore during their battle in the Ministry. Their first move in the duel is what Harris calls the "Rope of Fire." "I used this action, which is a dance movement called a rope spin. It's normally done with a girl," Harris laughs, "but in this case, it's a wand with some fire coming out of the end of it."

Voldemort's wand is perhaps the most menacing created for the films. It appears to be carved from a single, perhaps human, bone with a honeycombed midsection and a polished tip. The crook of a knuckle joint offers Voldemort the perfect place to hook his finger as he so delicately balances the wand above his head. "It's quite an evil shape," says concept artist Adam Brockbank.

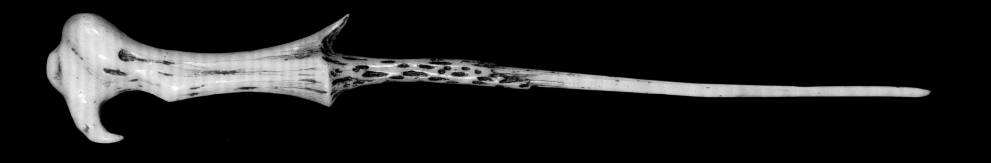

PETER PETTIGREW

Peter Pettigrew, an Animagus better known by his moniker "Wormtail," is responsible for tipping off the Dark Lord to the whereabouts of Harry Potter and his parents, leading to the deaths of James and Lily Potter.

The original casting for Peter Pettigrew's wand was carved from a piece of ebony wood, says prop modeler Pierre Bohanna. The design is that of a snake coiling inward on itself, with its coiled head creating the handle, and its tail serving as the tip of the wand.

Pettigrew casts one of the Unforgivable Curses in Little Hangleton Graveyard after the final Triwizard Tournament challenge in *Harry Potter and the Goblet of Fire*, when he does Lord Voldemort's bidding and incants *Avada Kedavra*, killing Cedric Diggory.

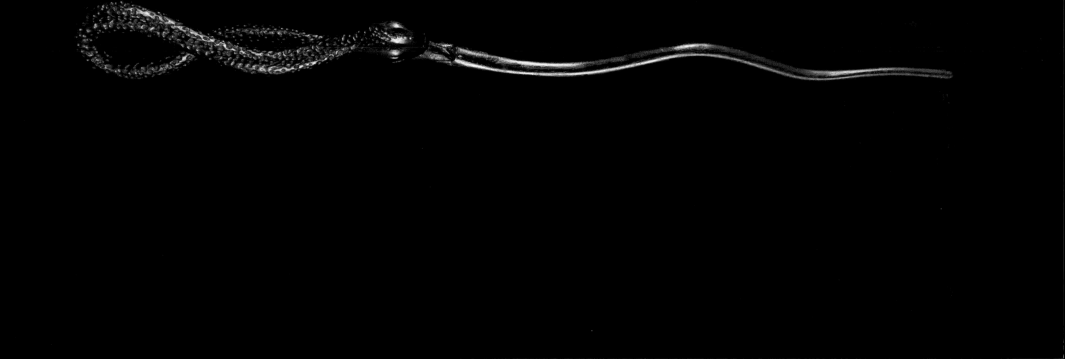

FENRIR GREYBACK

Fenrir Greyback is a vicious werewolf who has allied with Death Eaters and is responsible for infecting Remus Lupin with lycanthropy. Actor Dave Legeno described his character, Fenrir, as "a mercenary" for "using Voldemort to feed him new victims."

Fenrir's wand is a black-and-brown mottled wood with its handle marked by a newel-post top and a wooden ring with silver bands. The shaft is thick and comes to a rounded point at the tip.

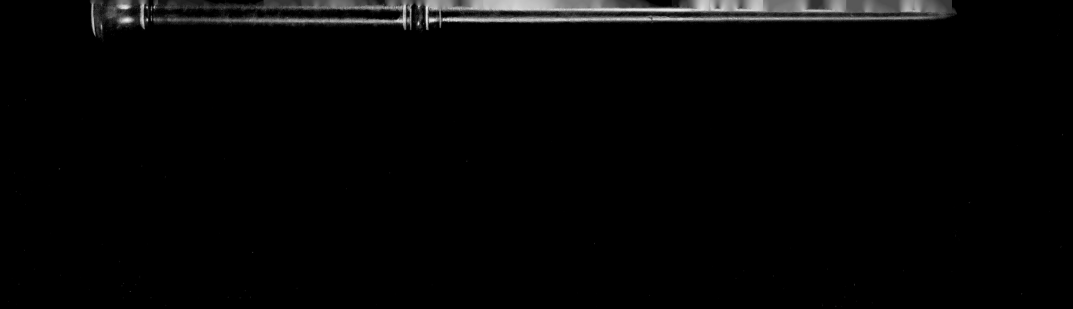

CORBAN YAXLEY

Corban Yaxley is a Death Eater who evaded imprisonment in Azkaban.

Peter Mullan, who plays Yaxley, was in the final scene shot on the last day of filming of the Harry Potter films, for *Harry Potter and the Deathly Hallows – Part 1*. He shoots a silver flash out of his wand at Hermione, Ron, and Harry as they attempt to escape from the Ministry of Magic. It is Ron's *Expelliarmus* Spell that disarms Yaxley and safeguards their getaway.

Yaxley's wand is economical, with sharp, flattened edges for newels and carved rings in its handle. A single silver band adorns its black length.

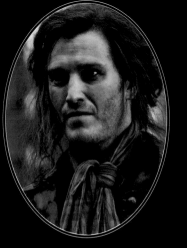

SCABIOR

The wizard Scabior leads a group of Snatchers who capture Harry, Ron, and Hermione in *Harry Potter and the Deathly Hallows – Part 1* following a chase in the Forest of Dean.

When Scabior brings the trio to Malfoy Manor, he and the other Snatchers are assaulted by Bellatrix Lestrange, who lashes out at them upon recognizing the Sword of Gryffindor. Scabior is disarmed in the skirmish and loses possession of his wand. Fighting alongside Lord Voldemort in the Battle of Hogwarts, Scabior appears briefly onscreen with a different wand.

Scabior's first wand is jet-black and jagged, as if it were formed from a piece of Obsidian glass. Its many nicks and worn-down areas suggest it has seen a lot of use and rough handling.

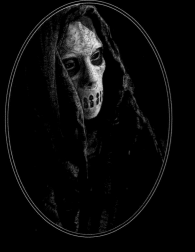

An elite group of pure-blood wizards and witches who pledge their loyalty to Lord Voldemort call themselves Death Eaters. Many landed in Azkaban prison, and then escaped during a massive breakout in *Harry Potter and the Order of the Phoenix.*

The filmmakers felt that Dark wizards deserved Dark wands. Concept artist Ben Dennett envisioned Death Eater's wands with a variety of menacing skeletal and serpentine features. Art director Hattie Storey drafted three basic types of handles and three types of sticks from which to cast hundreds of styles of wands from different colors and materials. The designs often reflect the serpentine Dark Mark or a variation on a skeleton. Some of the more showy wands complement the Death Eaters filigreed silver masks and menacing costumes.

When not incanting Dark magic or shooting spears of fire from their wands—as when they terrorize celebrants of the 422nd Quidditch World Cup in *Harry Potter and the Goblet of Fire*—many Death Eaters sheathed their wands in embroidered leather doublets that were outfitted with wand scabbards.

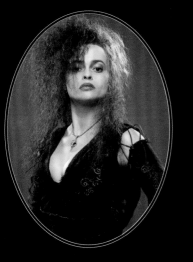

BELLATRIX LESTRANGE

Bellatrix Lestrange is a loyal Death Eater who escaped in a mass breakout from Azkaban prison in *Harry Potter and the Order of the Phoenix*.

Bellatrix is vicious with her wand and is responsible for the *Cruciatus* Curse cast on Neville Longbottom's parents prior to the story's events, as well as the murder of Sirius Black in the notorious duel in the Death Chamber during the Battle of the Department of Mysteries.

"I definitely have the best wand, don't I?" says Helena Bonham Carter. "My wand is warped. It sort of looks like another talon, like an extension of my manicure."

The wand features a gently curved handle inscribed with ancient runic symbols, but the tip appears to be honed from a massive bird of prey with its sharp, claw-like shape. Featuring a dragon heartstring core, the wand is described as "unyielding" by Ollivander in *Harry Potter and the Deathly Hallows – Part 2*.

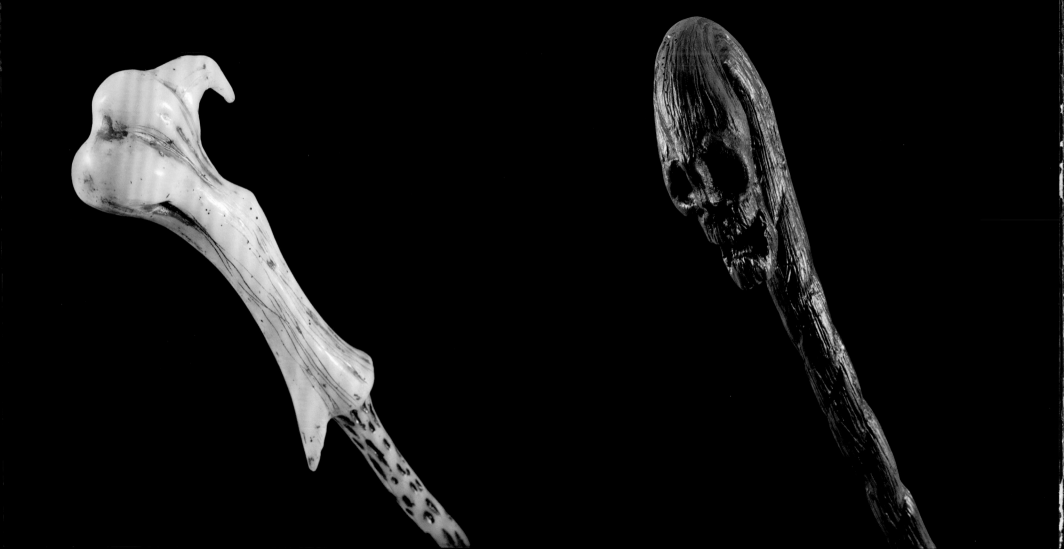

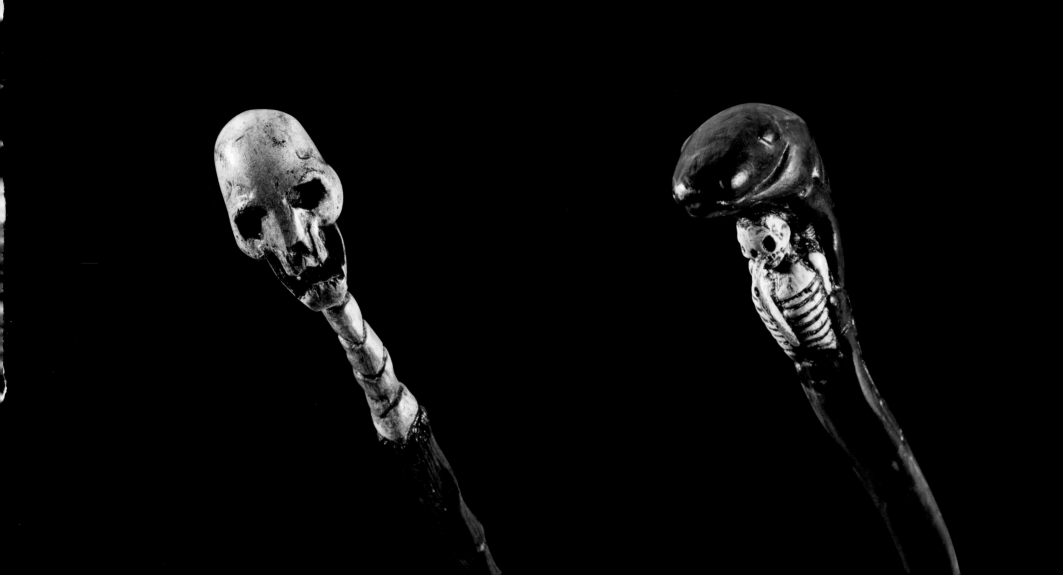

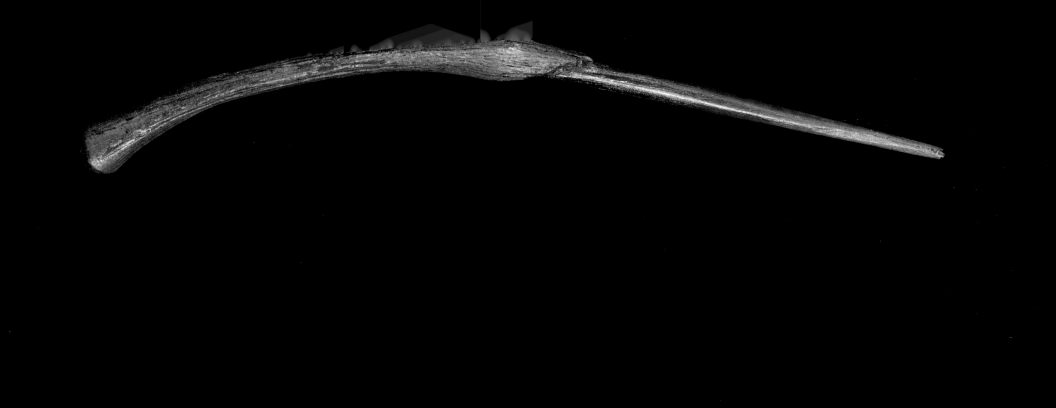

ALECTO CARROW

Death Eater Alecto Carrow served as Deputy Headmistress of Hogwarts under Headmaster Severus Snape in *Harry Potter and the Deathly Hallows – Part 1* and *Part 2*.

The base of Carrow's wand is decorated with a toothless, open-mouthed human skull, which leads into a handle resembling a spinal cord. The wand tip is made up of a dark and uneven wood.

Carrow's reputation landed her on the Ministry's Most Wanted list.

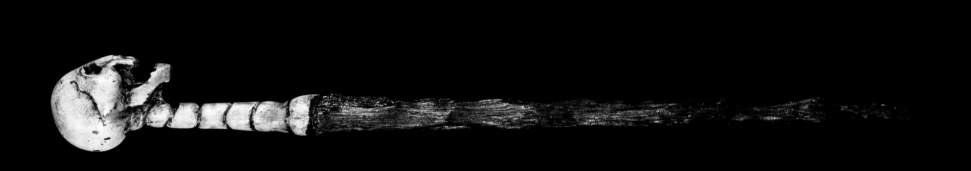

AMYCUS CARROW

Brother of Alecto Carrow, Amycus is a Death Eater and known associate of Lord Voldemort. He is present at Professor Dumbledore's death atop the Astronomy Tower in *Harry Potter and the Half-Blood Prince*. During Professor Snape's duel with Professor McGonagall in the Great Hall in *Harry Potter and the Deathly Hallows – Part 2*, Amycus and his sister flank Snape and are hit by spells deflected backwards by the professor.

Amycus Carrow's long, elaborate wand features a serpentine shape carved with scales. Its handle curves into the face of a snake at its base, and the handle features an ivory-white skeleton.

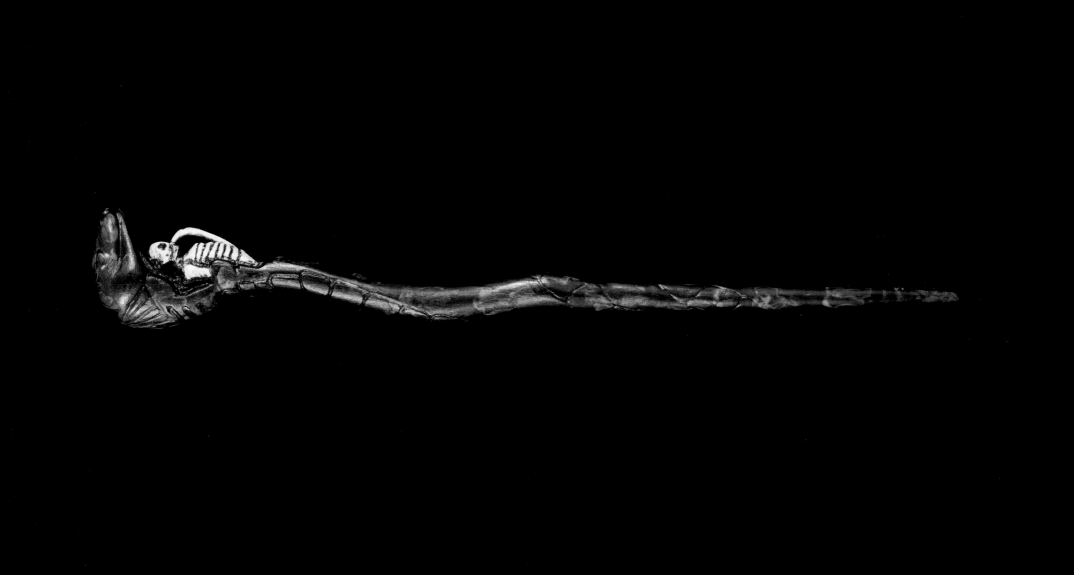

ANTONIN DOLOHOV

One of the Death Eaters who escapes in the mass breakout from Azkaban prison in *Harry Potter and the Order of the Phoenix*, Antonin Dolohov duels alongside Lucius Malfoy against Sirius Black and Harry Potter in the Battle of the Department of Mysteries.

In *Harry Potter and the Deathly Hallows – Part 1*, after tracking Harry, Hermione, and Ron to a Muggle café on Tottenham Court Road, Dolohov and fellow Death Eater Thorfinn Rowle enter dressed as Muggle workmen and attempt to catch the trio off guard with a surprise attack. The following skirmish is brief, ending with Hermione hitting Dolohov with a Full-Body-Bind Curse and Obliviating both Death Eaters. In the final film, Dolohov participates in the Battle of Hogwarts.

Antonin Dolohov's wand features a long, spiral-carved handle that snakes into a dramatic curve adorned with a skull.

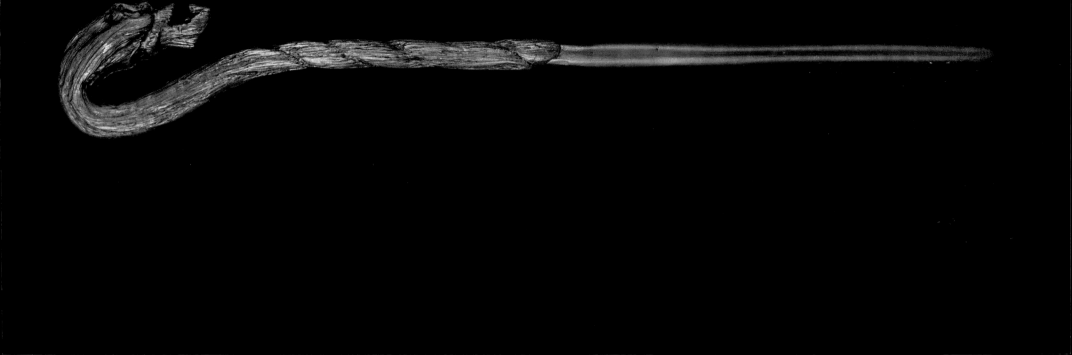

RUFUS SCRIMGEOUR

A renowned and courageous fighter against the Dark Arts, Rufus Scrimgeour serves as the Minister for Magic during the dark times of Lord Voldemort's return, succeeding Cornelius Fudge.

Actor Bill Nighy, who portrays Scrimgeour, describes his character as authoritative but with good intentions. "He's a soldier who has a new role, but one for which he may not be entirely fitted."

Scrimgeour bears the formidable wand of an Auror, with a heavy mahogany-colored hardwood. It is elegant and just; two weighted rings form the end of the handle, which is separated from the wand's shaft by a silver band.

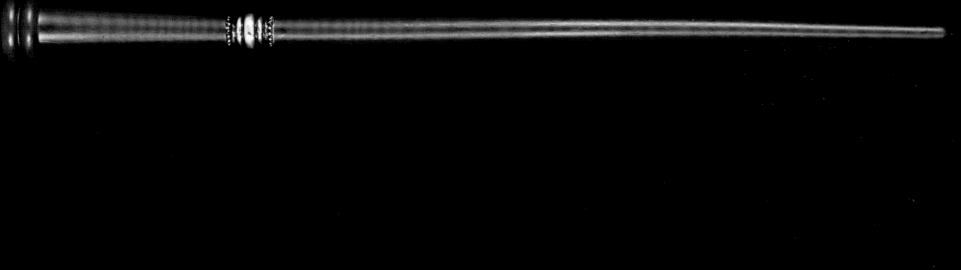

PIUS THICKNESSE

Instated as Minister for Magic in *Harry Potter and the Deathly Hallows – Part 1* after the death of Rufus Scrimgeour, Pius Thicknesse is key to the Death Eaters infiltration of the Ministry of Magic. "You will, I think, prove most useful, Pius," notes Voldemort during a meeting with his followers at Malfoy Manor.

In *Harry Potter and the Deathly Hallows – Part 2*, Pius dons Death Eater robes during the Battle of Hogwarts, where he is killed not by the opposing forces but by Voldemort himself. Frustrated by Pius's interruption, Voldemort punishes him with the Killing Curse.

Pius Thicknesse's wand features an elegantly curved handle set between two silver rings.

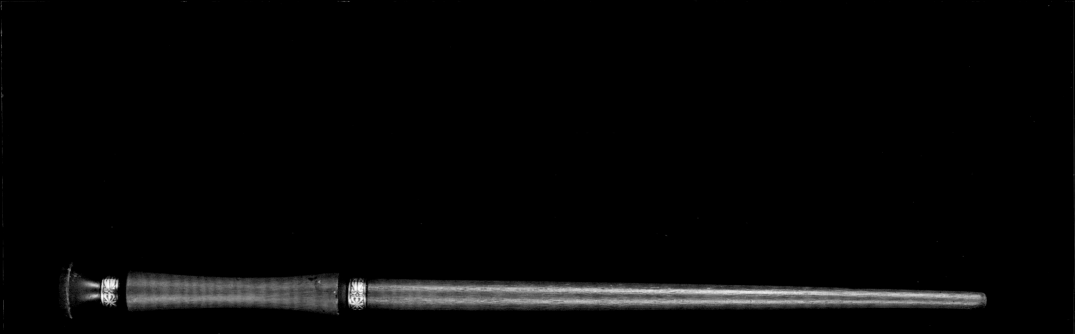

XENOPHILIUS LOVEGOOD

Xenophilius Lovegood is the father of Luna Lovegood and the editor of *The Quibbler* magazine, touted as the alternative voice for the wizarding world.

It seems that everything about Xenophilius has a peculiar twist to it, from the curvature of his cylindrical house to his wand, which twists like a unicorn horn, twirling with carvings of runic symbols along its length.

The prop modeler for Lovegood's wand, Pierre Bohanna, says it "captured his eccentricities."

MOLLY WEASLEY

Molly Weasley is the mother of seven children, wife to Arthur Weasley, and proud member of the Order of the Phoenix, with an exceptional talent for knitting.

"It's huge maternal stuff, to protect your children," says actress Julie Walters, "and that's what she's about." Walters found waving a wand around all day could become painful, but "I felt like a warrior with it." She knows it was all worth it during her fateful battle with Death Eater Bellatrix Lestrange in *Harry Potter and the Deathly Hallows – Part 2*.

Mrs. Weasley sports a modest wand: simple, practical, and well darkened with use.

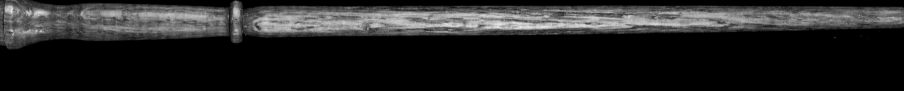

ARTHUR WEASLEY

Arthur Weasley, head of the Weasley clan, works at the Ministry of Magic. He has a particular affinity for Muggles.

The wand for the Head of the Misuse of Muggle Artifacts Office is a practical one with an elegant turn to it that prop designer Pierre Bohanna describes as "a sugar barley twist." Actor Mark Williams found it put a twist to his own style as well: right-handed Williams found himself always reaching for the wand with his left hand.

Even if his appearance seemed a little used and worn-out, Arthur's touch with his wand was not, as he proved battling a Death Eater during the Battle of Hogwarts.

Both the tip of the wand and the end of its twisted handle come to a flattop surface.

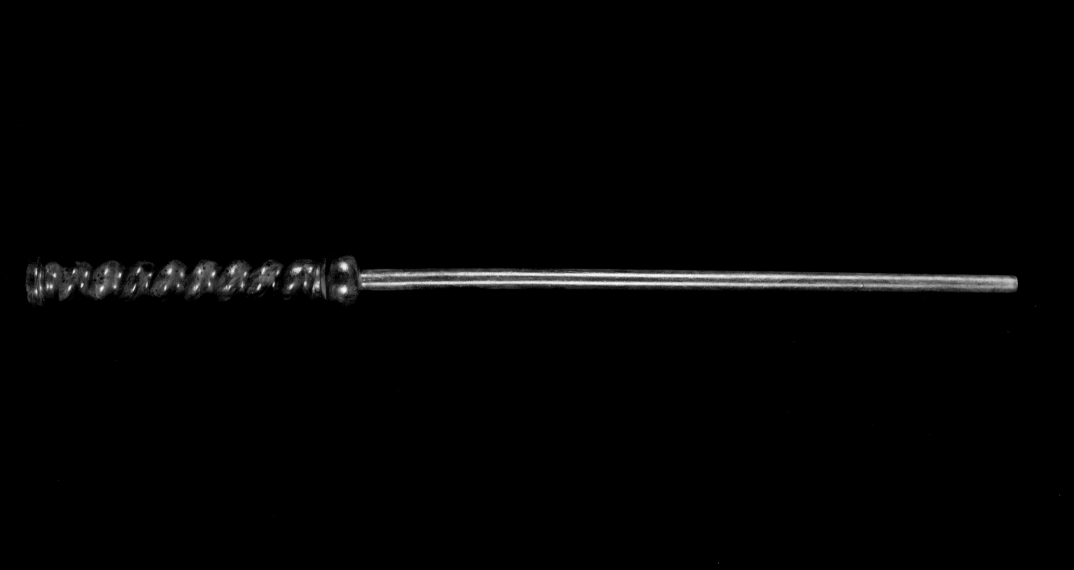

LUCIUS MALFOY

It is actor Jason Isaacs who first asked director Chris Columbus if his character could have a cane. Columbus asked, "Why, is there something wrong with your leg?" Isaacs replied, "No, I just think it would be good for pointing and gesturing and I could pull a wand out of it." So it is that Lucius's walking stick with its concealed wand became incorporated into his costume for the Harry Potter films.

Isaacs confesses he thinks his is the coolest wand in the wizarding world and that it makes his character, Lucius Malfoy, walk a bit taller.

Lucius is a known practitioner of the Dark Arts with his wand, including Unforgivable Curses. He attempted to perform the Killing Curse on Harry in *Harry Potter and the Chamber of Secrets*, but his once-enslaved house-elf Dobby interfered and repelled him.

The handle of Lucius's wand, a fang-bearing snake head, gleams with emerald gems—the color of Slytherin—for its eyes.

NARCISSA MALFOY

Though she is the sister of Bellatrix Lestrange and the wife of Lucius Malfoy, Narcissa Malfoy is a mother first, to Draco.

Narcissa's wand is fashioned of the same wood as her husband's. Silver bands and studs adorn the ebony shaft, finishing in a pyramidal tip, adding a distinctly feminine touch to the Malfoy family style of elegance and sophistication. "Narcissa is a pure blood, and in the world of Harry Potter, an aristocrat," says Helen McCrory, who plays Narcissa.

Narcissa fights fiercely beside Draco against Harry Potter and Ron Weasley in *Harry Potter and the Deathly Hallows – Part 1* as they try to escape Malfoy Manor.

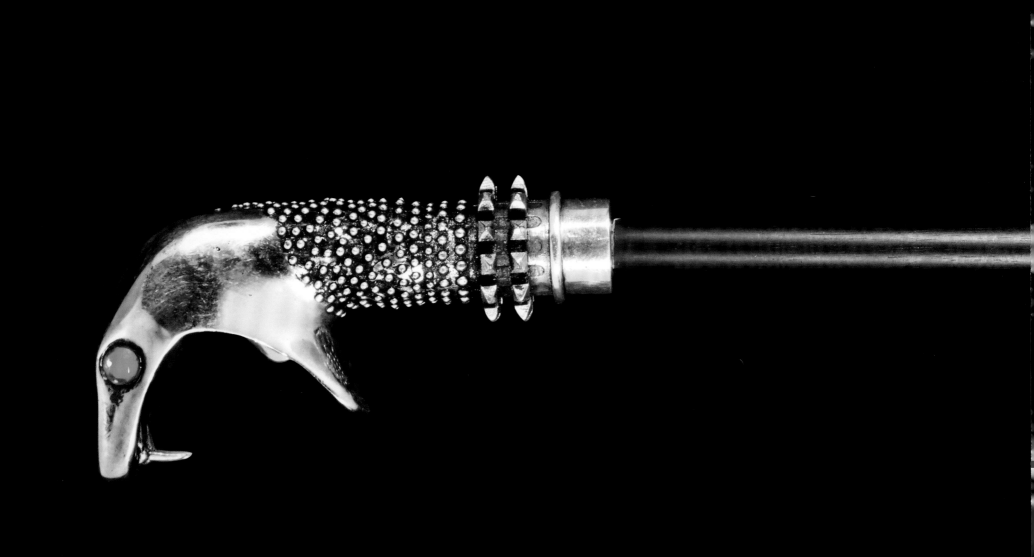

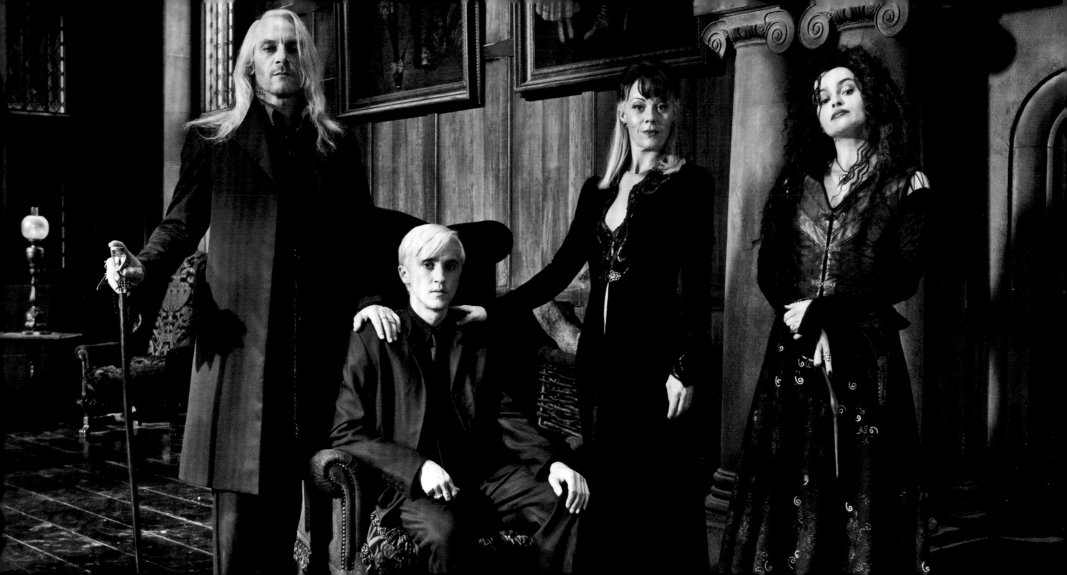

GARRICK OLLIVANDER

Master of wandlore and proprietor of Ollivanders wand shop in Diagon Alley, Garrick Ollivander is widely considered the most sought-after wandmaker in the entire wizarding world.

Ollivander remembers every wand he has ever sold. He knows better than anyone, as he tells Harry in *Harry Potter and the Sorcerer's Stone*, "it is the wand that chooses the wizard. It's not always clear why." It's Ollivander that explains the subtle laws of wand ownership to Harry in *Harry Potter and the Deathly Hallows – Part 2*, describing how Draco's wand responded to being won by Harry at Malfoy Manor. "I sense its allegiance has changed," remarks Ollivander.

Ollivander's wand features a gnarled, organic design, as if it was carved from a tree twisted with age. The wand's handle has a distinctive curve and is etched at its base with a few runic marks among the wizened wrinkles of the wood.

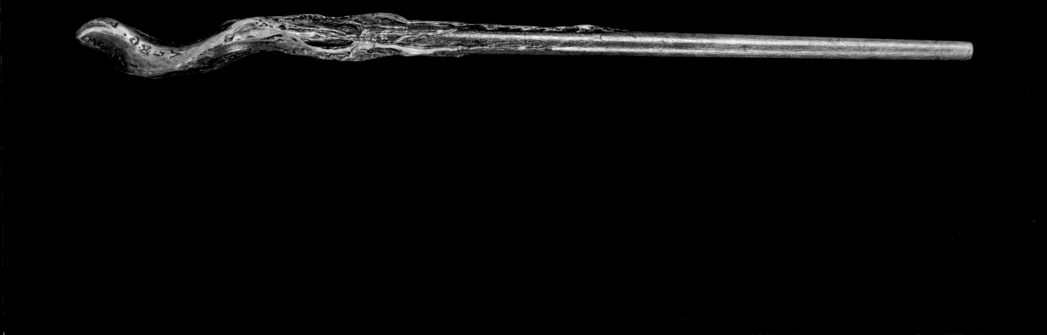

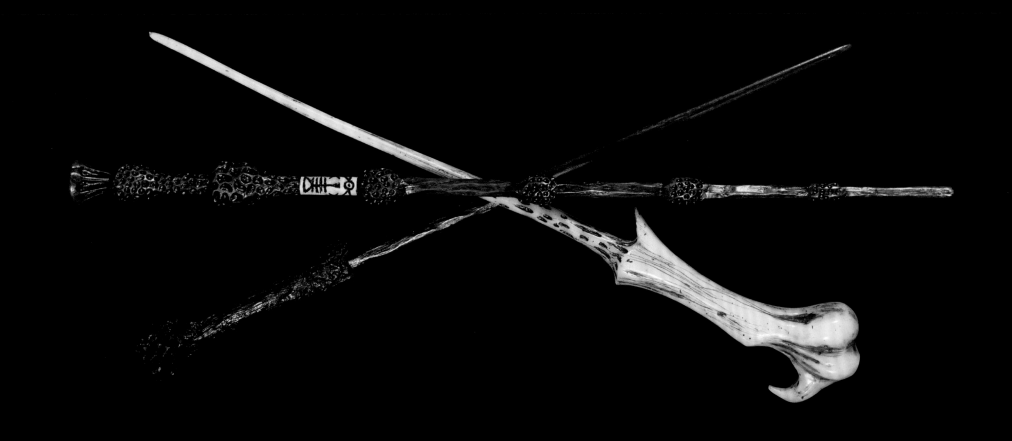

Conclusion

"You want magic to be real in life," says David Thewlis, who plays Professor Remus Lupin in the Harry Potter films. What is substantial about the Harry Potter films is that they touch on something slightly sinister—a darker side to life and death—and therefore something real. "And you want to be able to beat your enemies with a wand or with a thought or with something that's just simply not possible in real life." There is a reason why we love this wizarding world so much. We experience it with every aim of the wand. Thewlis calls it "hope."

Wand Index

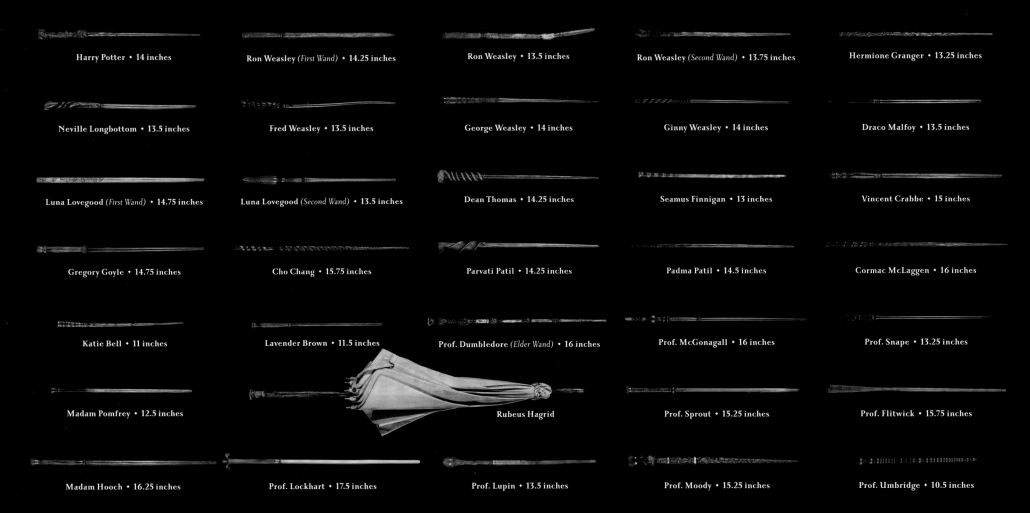

Harry Potter • 14 inches

Ron Weasley *(First Wand)* • 14.25 inches

Ron Weasley • 13.5 inches

Ron Weasley *(Second Wand)* • 13.75 inches

Hermione Granger • 13.25 inches

Neville Longbottom • 13.5 inches

Fred Weasley • 13.5 inches

George Weasley • 14 inches

Ginny Weasley • 14 inches

Draco Malfoy • 13.5 inches

Luna Lovegood *(First Wand)* • 14.75 inches

Luna Lovegood *(Second Wand)* • 13.5 inches

Dean Thomas • 14.25 inches

Seamus Finnigan • 13 inches

Vincent Crabbe • 15 inches

Gregory Goyle • 14.75 inches

Cho Chang • 15.75 inches

Parvati Patil • 14.25 inches

Padma Patil • 14.5 inches

Cormac McLaggen • 16 inches

Katie Bell • 11 inches

Lavender Brown • 11.5 inches

Prof. Dumbledore *(Elder Wand)* • 16 inches

Prof. McGonagall • 16 inches

Prof. Snape • 13.25 inches

Madam Pomfrey • 12.5 inches

Rubeus Hagrid

Prof. Sprout • 15.25 inches

Prof. Flitwick • 15.75 inches

Madam Hooch • 16.25 inches

Prof. Lockhart • 17.5 inches

Prof. Lupin • 13.5 inches

Prof. Moody • 15.25 inches

Prof. Umbridge • 10.5 inches

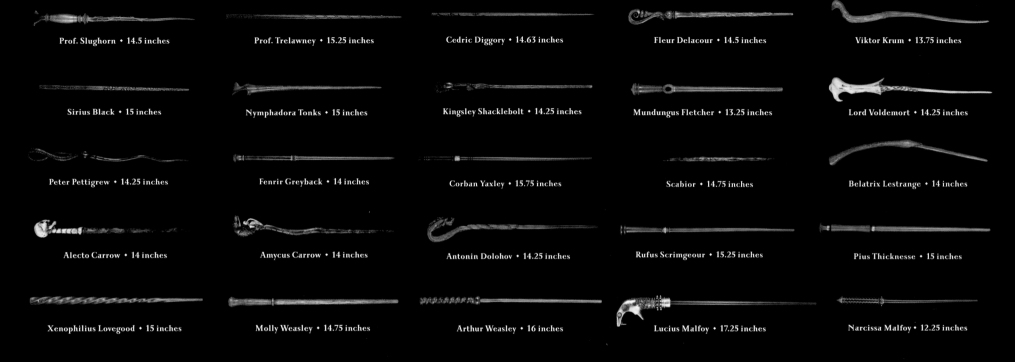

Prof. Slughorn • 14.5 inches

Prof. Trelawney • 15.25 inches

Cedric Diggory • 14.63 inches

Fleur Delacour • 14.5 inches

Viktor Krum • 13.75 inches

Sirius Black • 15 inches

Nymphadora Tonks • 15 inches

Kingsley Shacklebolt • 14.25 inches

Mundungus Fletcher • 13.25 inches

Lord Voldemort • 14.25 inches

Peter Pettigrew • 14.25 inches

Fenrir Greyback • 14 inches

Corban Yaxley • 15.75 inches

Scabior • 14.75 inches

Belatrix Lestrange • 14 inches

Alecto Carrow • 14 inches

Amycus Carrow • 14 inches

Antonin Dolohov • 14.25 inches

Rufus Scrimgeour • 15.25 inches

Pius Thicknesse • 15 inches

Xenophilius Lovegood • 15 inches

Molly Weasley • 14.75 inches

Arthur Weasley • 16 inches

Lucius Malfoy • 17.25 inches

Narcissa Malfoy • 12.25 inches

Garrick Ollivander • 14.5 inches

INSIGHT EDITIONS

www.insighteditions.com

Find us on Facebook: www.facebook.com/InsightEditions
Follow us on Twitter: @insighteditions

Published by Insight Editions, San Rafael, California, in 2020.

Library of Congress Cataloging-in-Publication Data available.

ISBN: 978-1-68383-988-0

Publisher: Raoul Goff
President: Kate Jerome
Associate Publisher: Vanessa Lopez
Creative Director: Chrissy Kwasnik
VP of Manufacturing: Alix Nicholaeff
Design Support: Judy Wiatrek Trum
Editor: Greg Solano
Editorial Assistant: Maya Alpert
Managing Editor: Lauren LePera
Senior Production Editor: Rachel Anderson
Senior Production Manager: Greg Steffen

Insight Editions, in association with Roots of Peace, will plant two trees for each tree used in the manufacturing of this book. Roots of Peace is an internationally renowned humanitarian organization dedicated to eradicating land mines worldwide and converting war-torn lands into productive farms and wildlife habitats. Roots of Peace will plant two million fruit and nut trees in Afghanistan and provide farmers there with the skills and support necessary for sustainable land use.

Manufactured in China by Insight Editions

10 9 8 7 6 5 4 3 2 1